Painting on Location

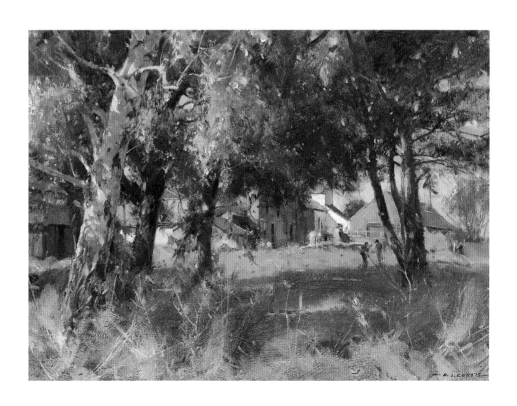

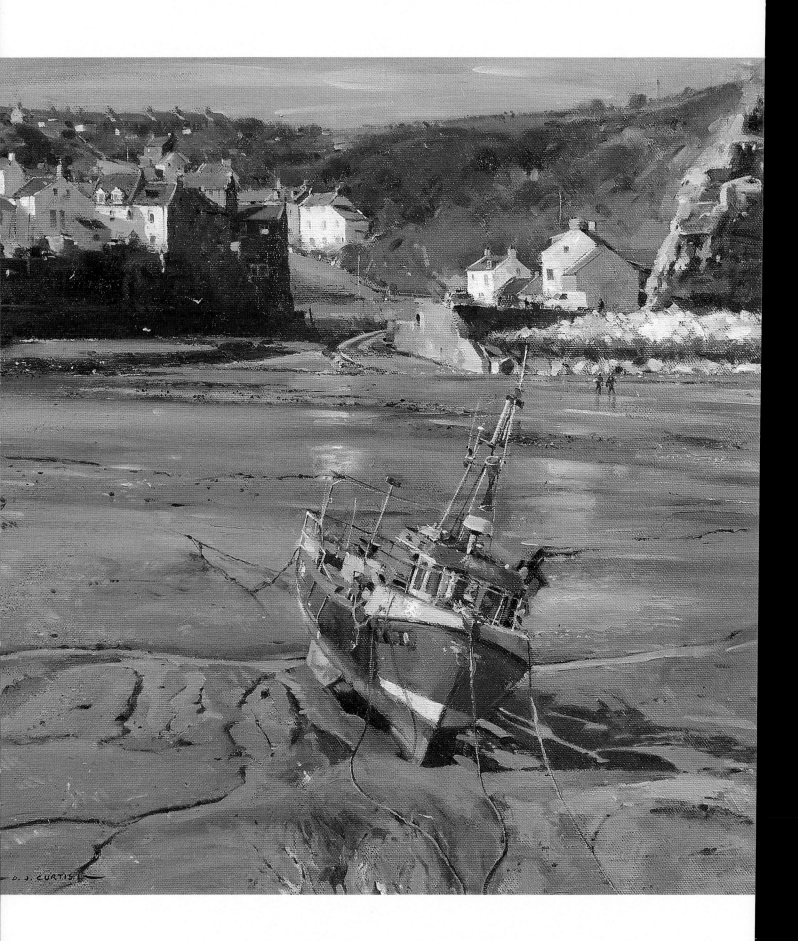

Painting on Location

David Curtis and Robin Capon

BATSFORD

To my family, friends and painting companions.
My special thanks to Robin Capon for his patient
hard work on the text.

www.djcurtis.co.uk

david@djcurtis.co.uk

First published in the United Kingdom in 2013 by
Batsford, 10 Southcombe Street, London W14 0RA
An imprint of Anova Books Company Ltd

ISBN 978 1 84994 071 9

A CIP catalogue record for this book is available from the
British Library.

20 19 18 17 16 15 14 13
10 9 8 7 6 5 4 3 2 1

Reproduction by Rival Colour Ltd, UK
Printing by Craft Print International Ltd

David Curtis is represented by Richard Hagen, Stable Lodge,
Broadway, Worcestershire WR12 7DP. Tel: 01386 853624
www.richardhagen.com.

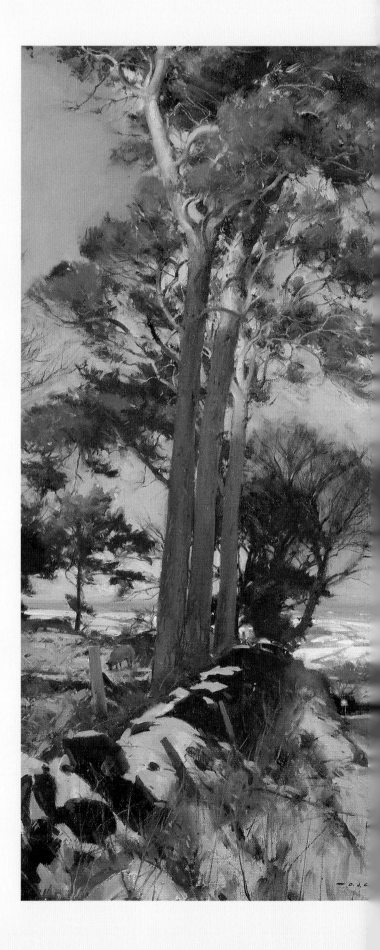

Half-title page *View Through the Copse, Jenkinsons' Farm*
Oil on board 30.5 x 40.5cm (12 x 16in)

Title page *Morning Low Tide, Staithes Harbour*
Oil on board 25.5 x 25.5cm (10 x 10in)

Right *Windswept Pines Above Sleights* (detail)
Oil on linen canvas 66 x 51cm (26 x 20in)

Contents

Introduction

I imagine that we all occasionally reflect on the most satisfying and pleasurable aspects of our life. For me, without doubt, the most fulfilling times are when I am outside in the landscape and have found an inspiring and challenging subject to paint. I have loved painting outdoors since my early teens, when I was given my first oil-painting set as a Christmas present. I soon discovered that oils can be used in a very direct, *alla prima* manner to capture the essence of a subject and that this approach was ideal for painting *en plein air* (in the open air).

Since those early days, the vast majority of my work has been based on the *plein-air* approach. Often I work entirely on site, or I might start a painting on site and finish it in the studio. It is the most rewarding and enjoyable way of working, I think. The advantage of painting outside is simply that you are there, 'living' the subject. In experiencing this heightened awareness of everything, you are able to paint with far greater sensitivity and conviction. In the studio, however, the experience is second-hand: you have somehow to recapture what it was like to be in a location, responding to a subject.

At its best, when painting on location, the work is totally absorbing: there is such a complete focus and intensity of purpose that you become unaware of anything else. And if the final painting captures the original inspiration and concept to a fair degree, the thrill of achievement can be quite sublime!

Of course, there are often added difficulties when painting outside, particularly concerning the light and weather. Naturally, time and comfort are far more limited than when working in the studio. For a beginner, early attempts at *plein-air* painting can seem very daunting and prove quite disappointing, but give it time and persevere. I know from my own experience that it takes time to build up confidence and develop the necessary aspects of technique and speed of working.

Right *Receding Tide, Staithes*
Oil on linen canvas
61 x 76cm (24 x 30in)
I always look for an exciting composition. With these breaking waves, I used a combination of careful observation and invention to create some strong, directional lines leading into the painting.

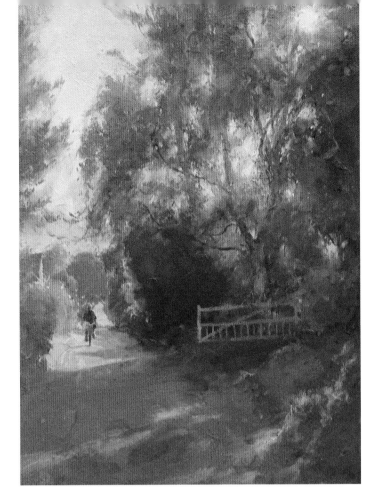

Above *A Quiet Ride Home*
oil on board
40.5 x 30.5cm (16 x 12in)
You don't have to go far to find
interesting *plein-air* subjects.
I painted this in the lane near
our house.

Above right David Curtis at work.

Even now, after more than 50 years' experience, I still have disappointing days occasionally. But the successful days more than compensate for that. What you learn is to accept the disappointments, re-motivate yourself and start a new painting. The more *plein-air* painting you do, the more you learn about choosing appropriate subjects and how to interpret them in a quick, lively and interesting way. It is important to go out painting as often as you can.

I paint in both watercolours and oils. Both are suitable for *plein-air* work, although for subjects in which I need to capture a fleeting light effect with speed and control, my preference is for oils. Where the key factor is atmosphere, but accuracy in depicting the shapes isn't quite so vital, I normally choose watercolour. It is good to have a choice of media, I think, because different media can bring out different qualities in a subject. Outside, I quite often start with an oil painting and then move on to work in watercolour, or vice versa.

I also used to work in pastel and pen and ink, and these too are excellent media for making *plein-air* studies. Incidentally, if you are not confident about starting directly with paint, take your sketchbook and some different sketching materials and begin with some *plein-air* sketches – perhaps later using these as starting points for some small paintings in the studio.

My principal aim in this book is to engender confidence, so that if you have not tried *plein-air* painting before or are relatively new to the idea, you will be encouraged to make some painting trips and see what you can achieve. The book includes information on all aspects of location painting, from practical considerations and equipment to painting techniques and capturing the essence of a subject. I hope it will help to prepare you for the wonderful painting opportunities that await you outdoors and inspire you to try this increasingly popular way of painting. There is no greater creative experience!

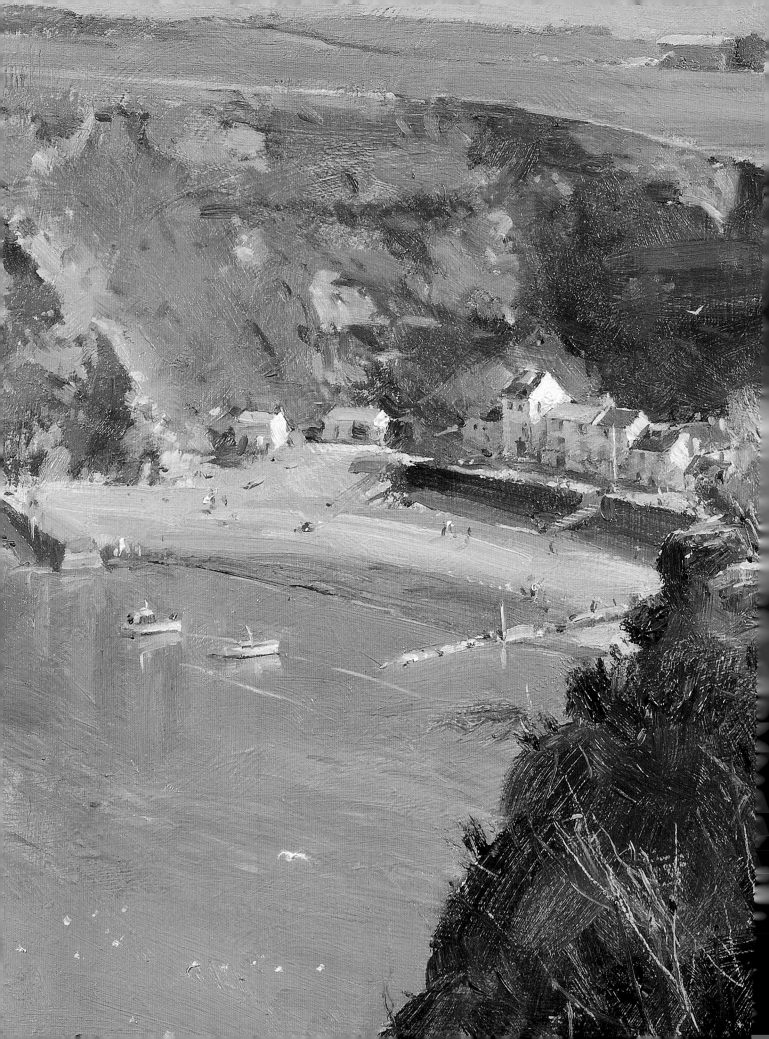

1. The Great Outdoors

When I started painting seriously, almost 50 years ago now, *plein-air* painting (painting in the open air) was a popular way of working. You would often see artists working directly from life outside, and this is how I learned to paint, working alongside experienced local artists. I was also lucky enough to paint with Edward Wesson, Jack Merriott and other nationally well-known artists of the time.

Throughout my career I have remained loyal to the *plein-air* approach and I continue to paint on the spot whenever I can, throughout the year and in all weather conditions. Like many artists, I think this method of painting is the best way to achieve a personal response to a subject. There is more edge and daring with *plein-air* work; it is a much more challenging way of painting than working in the studio. To quote a modern saying, you 'get into the zone' of the painting experience, and it can be quite spiritual. Equally, when painting outdoors, the surroundings, the weather, the sounds, the atmosphere and the sense of occasion all contribute to the vitality of the whole experience.

Left *Sheltered Harbour from the Nab, Staithes*
Oil on board
25.5 x 25.5cm (10 x 10in)
As time is always a key factor in *plein-air* work, it is important to have clear objectives for a painting and to stick to them. Here, my aim was to capture the contrasting qualities of texture and light between the transparency and fluidity of the water and the solid, structural nature of the enveloping cliff.

Painters and *plein-air* work

Something I have always admired about many of the great *plein-air* painters of the past, including Henry Scott Tuke and Stanhope Forbes, is the degree of finish that they managed to achieve. And they did that without having to resort to photographs as back-up reference, as we might do today. Also, they weren't afraid to work on a big scale and so have to return again and again to a location until the painting was completed. Today, we can only marvel at their painting ability and at their incredible powers of observation and draughtsmanship. The immense skill and fluency of their work remains an inspiration.

Together with particular skills, *plein-air* painting also requires confidence and discipline. It is often an intense process, largely because of the constraints of time, light and other practical considerations, requiring quick judgements and a focus on essentials. It takes time to develop those skills: consistent practice over many years. Unfortunately, especially now that most of us have digital cameras, it is tempting to spend less time outside and work more from photographs. This practice must be kept to a minimum, I think. It is very difficult to capture the moment, and to paint with strokes that have life, meaning and integrity, when detached from the subject matter.

Below *Lane in Winter, Harwell*
Oil on board
20.5 x 30.5cm (8 x 12in)
For speed and spontaneity when using oils, don't be afraid to work with large, blocky brushstrokes. My own preference is to use short-haired brushes – mainly brights (which have short bristles of equal length arranged in a flat, rectangular shape).

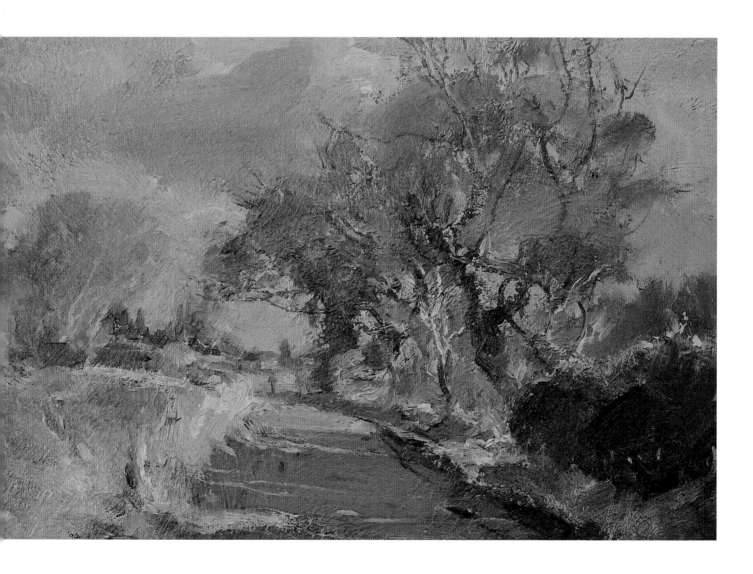

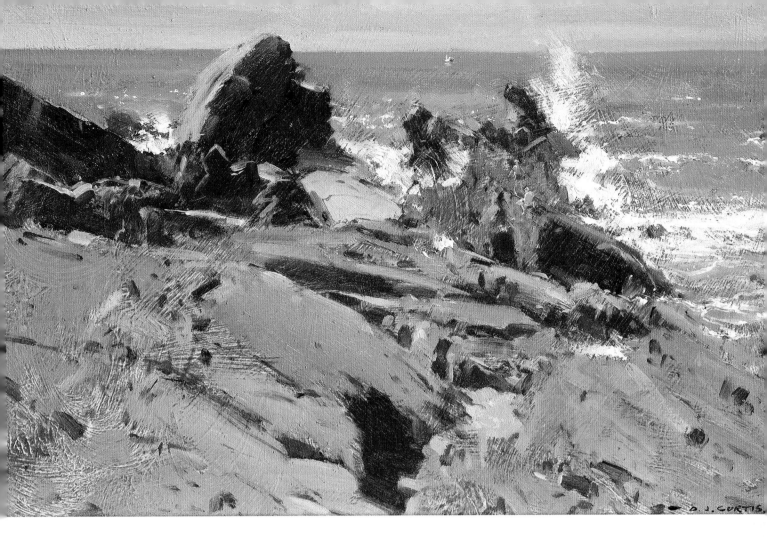

In my view, you are far more likely to create a painting that evokes feeling and atmosphere when you are actually there, working on the spot and in tune with the sense of place and mood. I aim to do that for at least the greater part of each painting's execution. *Lane in Winter, Harwell* (opposite) demonstrates this point – it has that sense of immediacy. Its success, as is so often the case with *plein-air* works, relies on confident, big brushstrokes, most of which were made with a slightly worn, short bright brush. (A bright is a flat brush with short bristles.) For example, the hedge in the bottom-right corner was suggested with just one or two large, blocky brushstrokes. Similarly, *Crashing Waves, Bude* (above) shows a very direct response and a considered choice of subject matter, resulting in a profoundly satisfying composition.

History and inspiration

Painting and sketching in the open air became popular during the nineteenth century, particularly with groups such as the Barbizon painters and later the Impressionists and the Newlyn School, although also with individual artists such as Constable, who sought 'truth in nature'. Its popularity was aided by the introduction, in the 1870s, of paints in tubes and easily portable painting equipment, notably the box easel. Since then, many different art movements have come and gone, but painting on location has remained popular, especially in Europe and the United States.

Most of the painters who have inspired me belong to the British school – artists such as Harold and Laura Knight, who used to paint at Staithes, which is one of my favourite

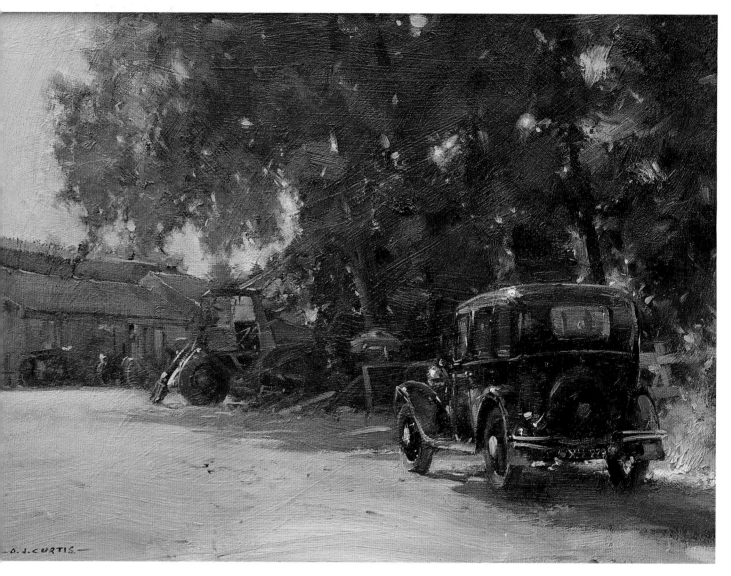

locations. And because, usually, it is the particular quality of light that attracts me to a subject, I have always loved the work of the Impressionists, especially that of Monet and Pissarro. Also, more recently, I have discovered several Finnish artists whose work I admire, amongst them Victor Westerholm, Albert Edelfelt and Eero Järnefelt. Like me, you will find that there are plenty of *plein-air* artists, both contemporary and from previous eras, whose work can be inspirational.

Plein-air painting today

It is encouraging that *plein-air* painting continues to attract many of the finest artists in the world and that there are various groups of artists devoted to this approach – for example, the Wapping Group in the UK, or the Plein-Air Painters of America and the National Academy of Professional Plein-Air Painters in the USA. I am now more optimistic about the future of *plein-air* painting. There is evidence of a renewed interest in it, especially amongst younger landscape painters. I have noticed this in the submissions that are received for some of the major open exhibitions, when I have been working as one of the selectors.

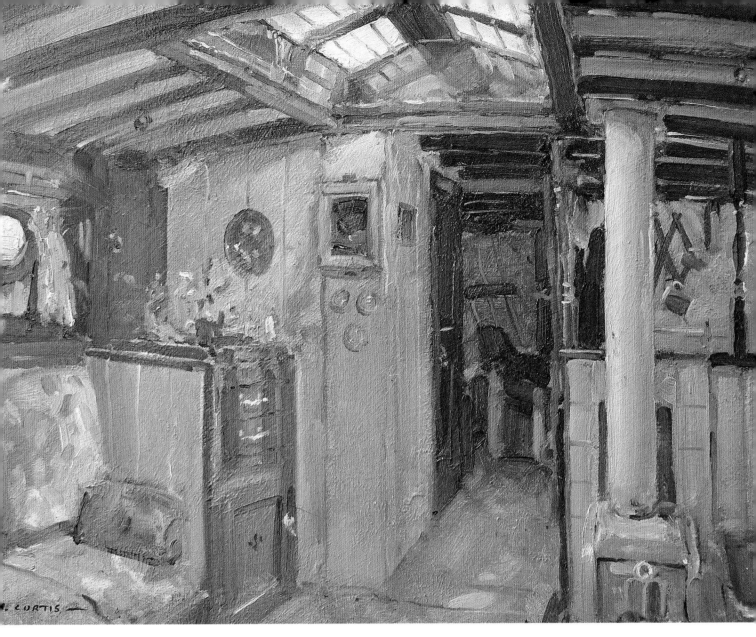

Some artists are turning to *plein-air* work as a reaction against technology and from a wish to achieve a more direct response to subjects. But there are different approaches, and not all artists want to paint entirely on the spot. Instead, they might gather lots of reference material on site (sketches, tonal studies, small colour 'notes', try-outs and so on), all of which will be useful later when they come to paint the final picture in the studio. During that process, they might decide to move things around or leave things out, in order to arrive at a strong, interesting composition borne out of experimentation and a thorough consideration of all the possibilities.

In contrast, there are other artists who are not afraid to carry huge canvases into the city or the countryside and to paint exactly what they see. My aim is to reach a conclusion on the spot – to capture the moment, convey the essence of the subject. I hope I can minimize any further work back in the studio, although this is not always possible. I think an important point to remember when painting on location is to be faithful to your reaction to what is there, which is not the same as being faithful to what is actually there. I like to focus on what I feel and consider is important about a subject.

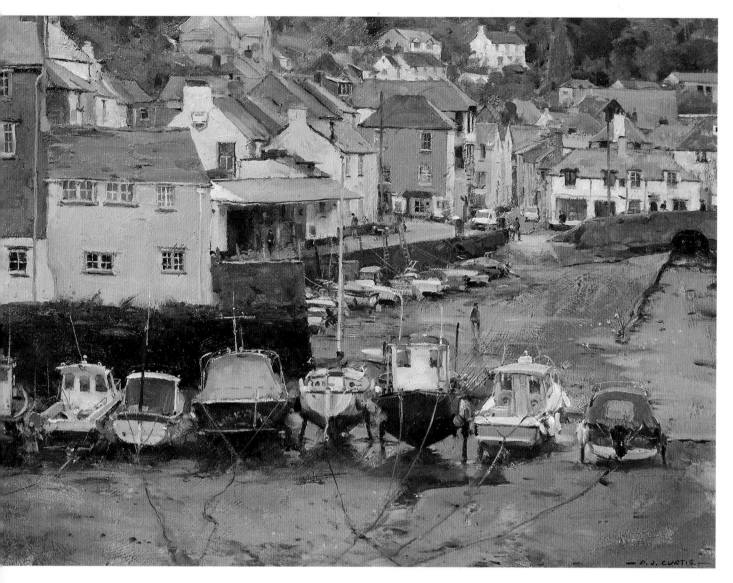

Above *The Harbour, Polperro*
Oil on board
30.5 x 40.5cm (12 x 16in)
For this high-aspect, complex subject, and with the advantage of being able to work from a shelter, I was able to take a little more time than usual, enjoying painting sessions on two consecutive days.

Scope and advantages

The scope for location painting is tremendous: just think of the many different subjects that are found outdoors, from gardens and landscapes to buildings and city scenes. Certainly for me the advantages of *plein-air* painting lie in its very nature – the fact that you have to adopt a fast-and-loose approach, working on a small scale and aiming to express a response to a subject in a direct, non-fussy way. I like the challenge of painting on site and, as I have said, I enjoy the whole experience of being outside with all that it entails. Inevitably, *plein-air* painting requires a sense of urgency to capture the essence of a subject before the light changes or conditions radically alter, and that is something I relish.

Your ambitiousness in location work (and consequently the choice of subject matter, scale, medium and approach) will largely be determined by the degree of confidence you have, taking into account the light and weather conditions and the likely amount of time

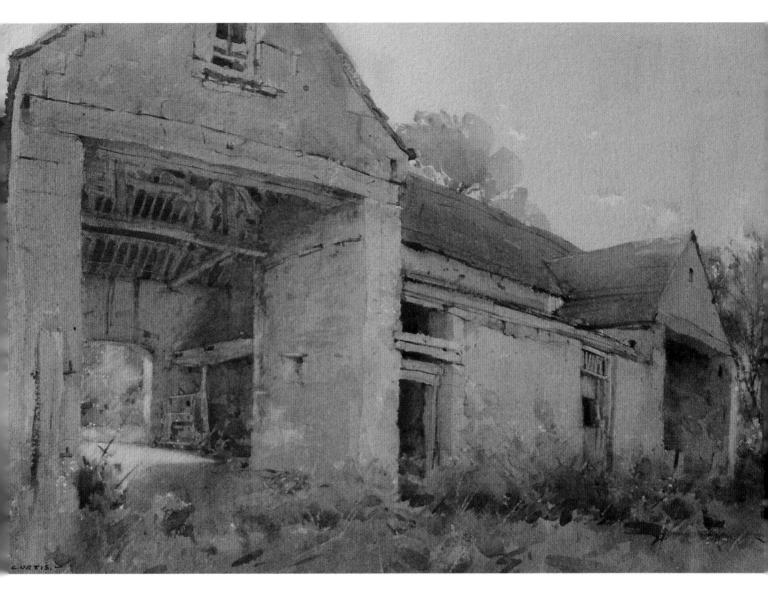

available. For example, when the light is dull and fairly constant there is always more time to work on a painting, and in turn this might tempt you to try a more challenging subject.

I started painting *The Harbour, Polperro* (opposite) on a dull day, setting up my box easel under the shelter above the harbour. The tide was out, so the conditions were favourable for attempting a much more detailed and considered painting than usual. Moreover, from my sheltered position, I knew I would be able to return at the same time the next day to complete the painting. In contrast, time was very limited when I painted *Windrush Mill* (page 16), as it was raining and so I had to work quickly, under the limited shelter of an umbrella. The light and weather conditions always play a part in influencing the scope, content and character of a painting and, if possible, they are qualities to embrace rather than fight against.

Above *A Cotswold Barn, Little Barrington*
Watercolour on Arches Rough paper 38.5 x 57cm (15¼ x 22½in)
Completed entirely on site, this watercolour painting took about three and a half hours. I decided to work from a low viewpoint so that I could include the added interest of the beamed roof structure and the sense of light coming through the far door.

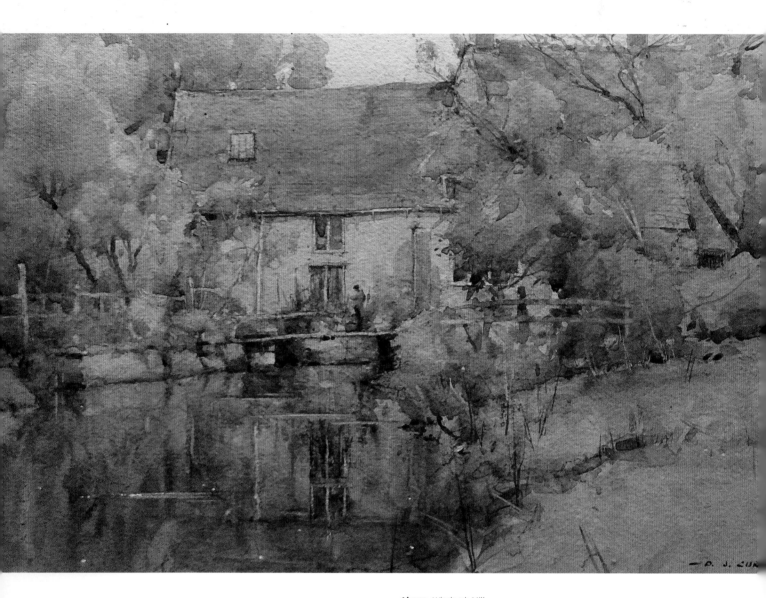

Above *Windrush Mill*
Watercolour on Two Rivers tinted paper
28.5 x 38.5cm (11¼ x 15¼in)
It was raining when I painted this subject,
so, of necessity, I had to work under a large
umbrella. Given the conditions, I thought
that the painting would work best as a more
intimate, close-up view.

A direct response

One of the main advantages of painting on site is that inevitably you become part of the scene and therefore much more aware of the mood of the subject and all the factors that contribute to that mood – the light, colours, textures, weather, sounds and so on. This puts you in a strong position to capture those particular effects in the painting – if you are in tune with a subject, this is bound to be reflected in the way that you work. Take *Willows on the Idle, Misson* (above), for example. This is a subject that I know well, not far from my studio. It was a dull, blustery day and I wanted to evoke that sense of wind and movement in the painting. I wanted to create another dimension to the work – not just the look of the subject, but also the feel of it. Consequently I adopted a technique that would help to convey that windswept feeling, for the most part using staccato brushwork (short, quick touches of colour) and lost-and-found effects (soft, feathered-out brushmarks combined with more defined ones).

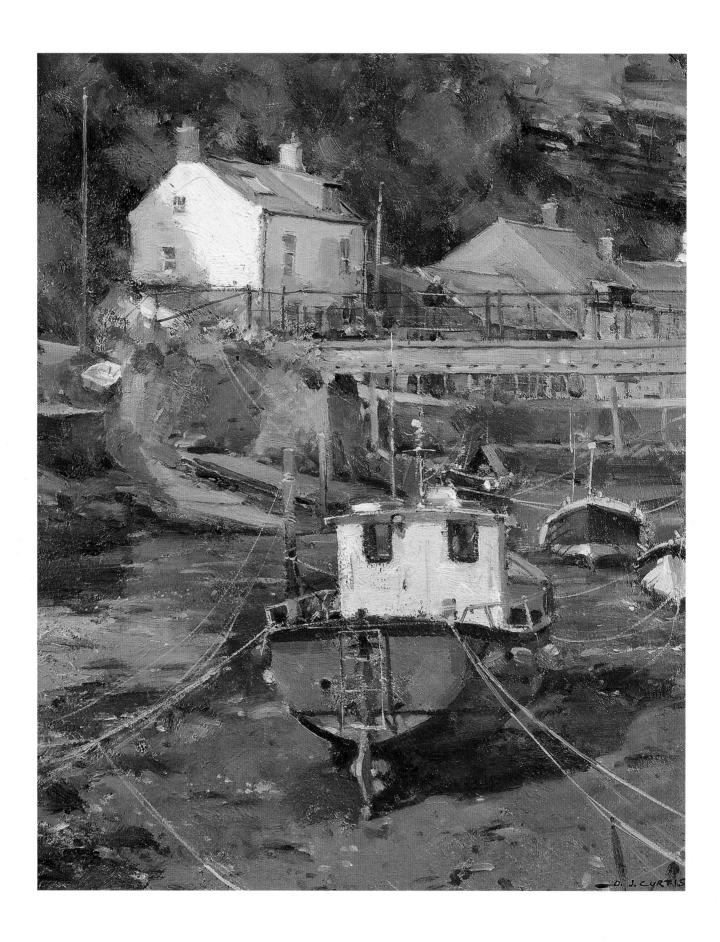

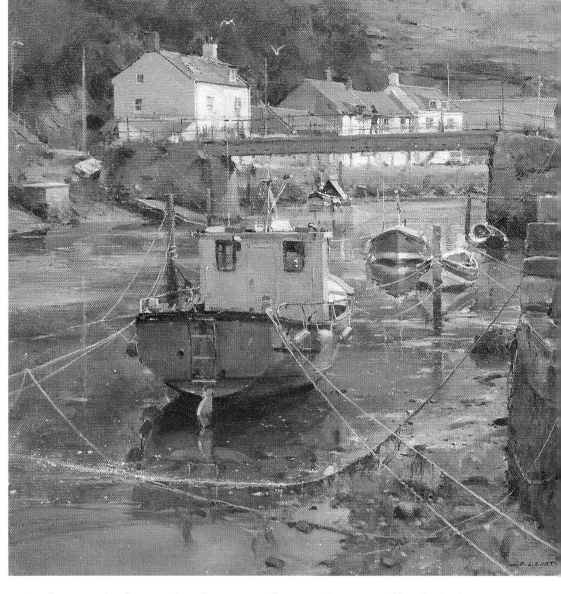

Opposite *Late Afternoon Sun in the Beck, Staithes*
Oil on board
30.5 x 25.5cm (12 x 10in)
Influenced by weather, light, changing tides and other conditions, a simple subject can take on many different guises and so offer lots of variety for *plein-air* paintings. Here, the late afternoon sun, warm and low, created a stunning play of colours and shadows.

Right *Morning Sun and Receding Tide, Staithes*
Oil on board
40.5 x 40.5cm (16 x 16in)
After painting *Late Afternoon Sun in the Beck, Staithes* (opposite), I returned the next morning to find completely different light and tide conditions, so that the subject was viewed *contre-jour* and there was a greater emphasis on tonal changes and reflections.

Staithes is another location that I know very well – I must have painted hundreds of *plein-air* works there. But even when I choose the same view, as I did for *Late Afternoon Sun in the Beck, Staithes* (opposite) and *Morning Sun and Receding Tide, Staithes* (above), because of the changing light and tide, there are always different qualities to exploit. For *Late Afternoon Sun in the Beck, Staithes* the tide was out, while the strong sunlight emphasized the colours and tones. I particularly liked the relationship between the colour of the pantile roofs and the foreground boat. In contrast, for *Morning Sun and Receding Tide, Staithes*, the effect of the light was *contre-jour* (into the light), creating a greater emphasis on tonal values rather than colour and, with a low tide, the inclusion of reflections rather than shadows.

Above *The Monastery, Valdemosa, Mallorca*
Oil on board
25.5 x 30.5cm (10 x 12in)
This was a complex subject, but because it was quite distant, I could express it as a series of block shapes of subtly differing tones.

Practical considerations

Although enjoyable and extremely rewarding, painting outdoors is seldom easy: it is radically different from working in the studio environment, with its advantages of comfort, time, and access to a wide range of materials and equipment. However, if you are well prepared, there is nothing quite like the thrill, experience and sense of achievement gained when painting outside.

Being well prepared means thinking about what to take in the way of materials, your own comfort in terms of clothing and food, and the location, likely subject matter and associated factors that may influence the work, such as weather and tides. I know that when I first started painting *en plein air*, with the enthusiasm and energy of youth, I was prepared to carry vast loads over long distances. But now, influenced by thousands of hours working in difficult weather conditions, I have pruned the equipment to far more sensible levels of bulk and weight! For instance, for oil painting, I now usually take a small, half-box easel out with me, rather than a full-sized one, or I work from a pochade box, a small, portable wooden box that holds all the essential *plein-air* materials. And I only take the essential colours, brushes and so on. With watercolours, weight is rarely a problem, but again, I only take what is essential.

It takes a degree of courage to go out painting on your own, so initially I would advise joining a painting group or taking a painting companion with you. Also, I think it is prudent not to be too ambitious with subject matter to begin with. Choose subjects that you are reasonably confident of finishing and achieving some success with in the time available. You could take a small cardboard viewfinder to help you select the scene that you want to concentrate on. Look for a strong, interesting composition, with a lead-in foreground feature. Focus particularly on sound drawing, the relative scale of things, tonal contrasts and a broad painting technique, and give yourself a reasonable time limit – no more than two hours. A small, intimate subject, as in *The Olive Grove, Puerto Pollensa, Mallorca* (page 21) is great for *plein-air* work. I painted this entirely on site, in oils, on a 17.5 × 25.5cm (7 × 10in) prepared board. I was fascinated by the tortured shapes of the olive trees and the simplicity of the little barn in the distance.

Below *Newquay Harbour*
Oil on board
23 × 30.5cm (9 × 12in)
I like *contre-jour* subjects. As here, they often include dramatic contrasts of lights and darks that will add immense impact, yet retain a simplicity, in a painting.

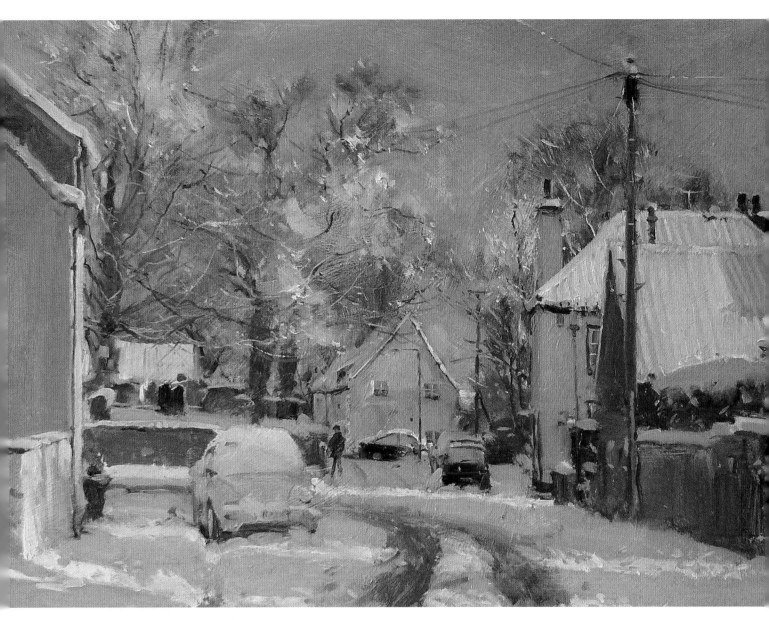

Above *Winter 2010, Misson*
Oil on board
25.5 x 35.5cm (10 x 14in)
Snow will add a completely new dimension to an otherwise quite ordinary scene, and depicting it allows you to paint quickly and broadly – which is just as well in the very cold conditions!

Light and weather

The weather – and consequently the quality of light – always plays a significant part in determining the choice of subject matter and how it is painted. Here, as with all aspects of painting, experience is the key factor. The more you paint outside, the better you become at judging the weather and deciding on what sort of window of opportunity there is time-wise and, taking that into account, what sort of work is possible. In fact, if you are properly prepared and dressed appropriately, should you wish, there is no reason why you shouldn't be able to paint in almost any kind of weather.

Wind and rain are generally the most challenging conditions in which to paint. With your canvas or board buffeted by wind, and similarly your hand and body, it can become very difficult to create the expressive strokes and subtle effects that you would like. However, often the sense of urgency and risk will translate through the brushstrokes and add extra

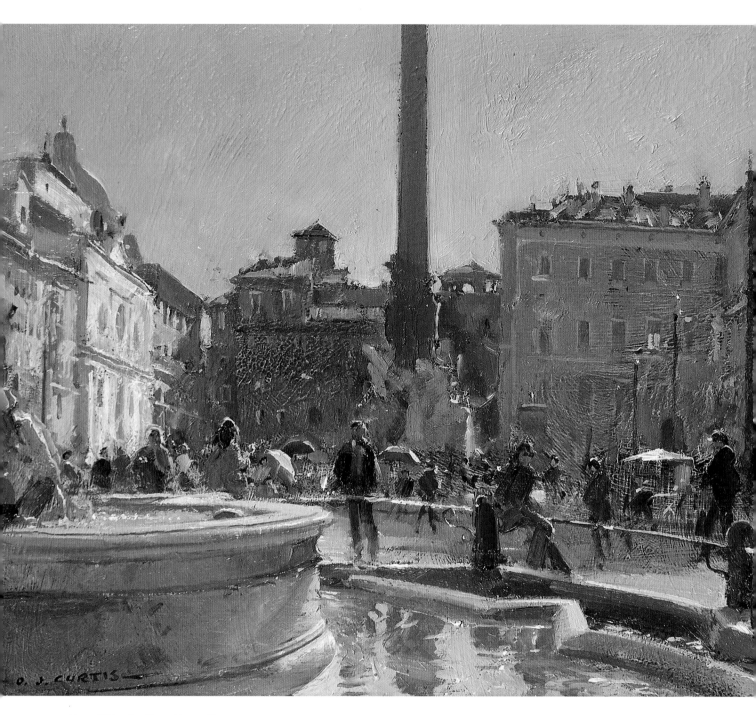

Above *Winter Sun, Piazza Navona, Rome*
Oil on board
20.5 x 30.5cm (8 x 12in)
Architectural subjects rely on very sound drawing
ability. Additionally, for this painting, there was the
challenge of incorporating figures, which had to be
worked with the same type of paint application as
the rest of the painting.

'punch' to the final result. Obviously, rain is particularly damaging to watercolours, although if the rain is not too heavy or persistent you can always work from the shelter of a large umbrella. Another problem with rain, of course, is that in damp conditions watercolour paints dry very slowly.

Conversely, when it is very hot, watercolour dries quickly and you have to adjust your technique accordingly – essentially working wet into wet with liberal washes of colour. I have painted in extremely hot conditions in continental Europe, in temperatures of around 38°C (100°F). That can be quite a test of endurance, as can painting in temperatures at the other extreme, in freezing conditions. But every type of weather and light brings something new to try out in a painting. Extreme weather creates a different atmosphere and, as in *Winter 2010, Misson* (page 23), it can add a completely new, interesting dimension to an otherwise quite ordinary subject.

Above *Small Boats in the Outer Harbour*
Oil on board
20.5 x 30.5cm (8 x 12in)
This was a quick, 40-minute painting made just after dawn on a cold and windy October day. I often find that some of my most successful paintings are made very early or very late in the day, when the quality of light is more challenging and also more inspirational.

Critique

High Viewpoint over the Beck, Staithes

Because I often paint at Staithes, I am sometimes asked if I have exhausted all the possible subjects there. I am confident that I never will! Staithes is a wonderful place because it offers such variety – high-aspect and low-aspect subjects, intimate and general views, the variety created by changing light and tides, and so on. Sometimes there is a white light, like the light in Cornwall, sometimes the light is very diffused, and sometimes light and weather are extremely challenging. But there is always something exciting to paint, and this is greatly helped by the fact that I know the location and therefore what is likely to appeal and be successful as a subject, given the conditions on the day.

I always look for a strong sense of design in a subject, and I thought the view I found for this painting, from a high aspect, taking in the sweep of the river, would give a very bold, exciting composition. The contrasts of light added to the drama of the scene. I decided to work on a square board, rather than the usual landscape format, as this would enhance the dynamic of the composition.

I began by making a very small sketch in a corner of the board, about 10cm (4in) square, just to get a feel for the composition and the main light/dark relationships. Then I rubbed out the sketch and started in oils by placing the main light areas, using a mix of Naples yellow, yellow ochre and white. For the rest of the painting, I concentrated on capturing the play of middle tones, although another interesting feature was the reflection of the sky in the water. This created an exciting interaction of near-complementary colours, between the blue and the yellow/gold of the pantile roofs. I worked on the painting over a two-day period, from 1.30pm to about 4pm each day. On the first day I managed to complete all the basic blocking-in of the painting, which I call the spadework period. Then, on the second visit, I worked on the nuances of tone, colour and detail – which is always the most enjoyable and potentially satisfying part.

Right *High Viewpoint over the Beck, Staithes*
Oil on board 40.5 x 40.5cm (16 x 16in)

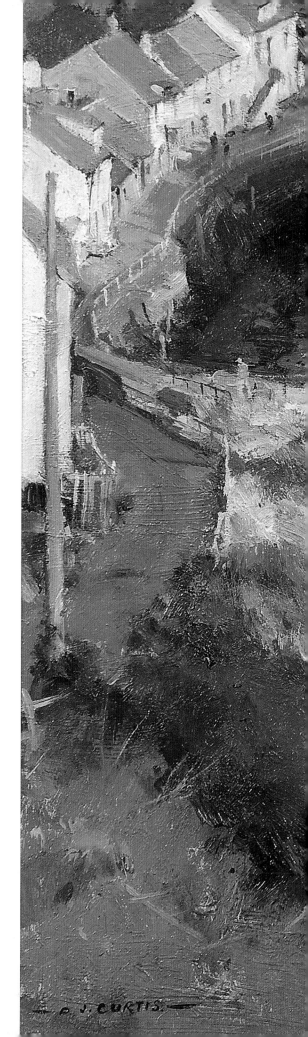

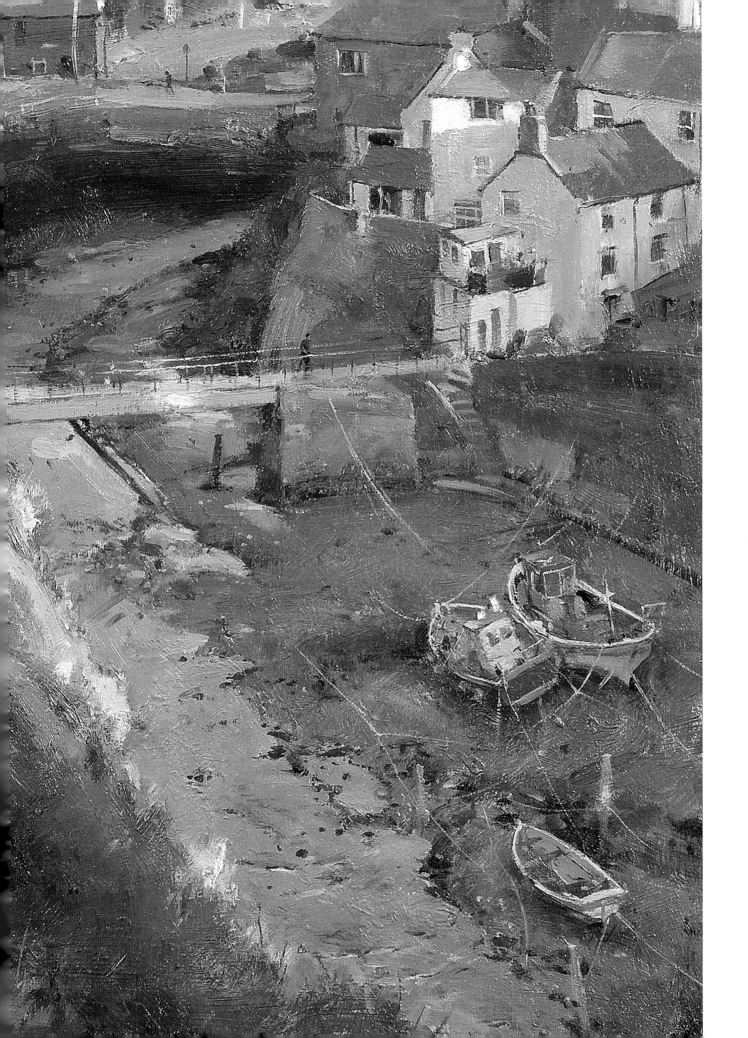

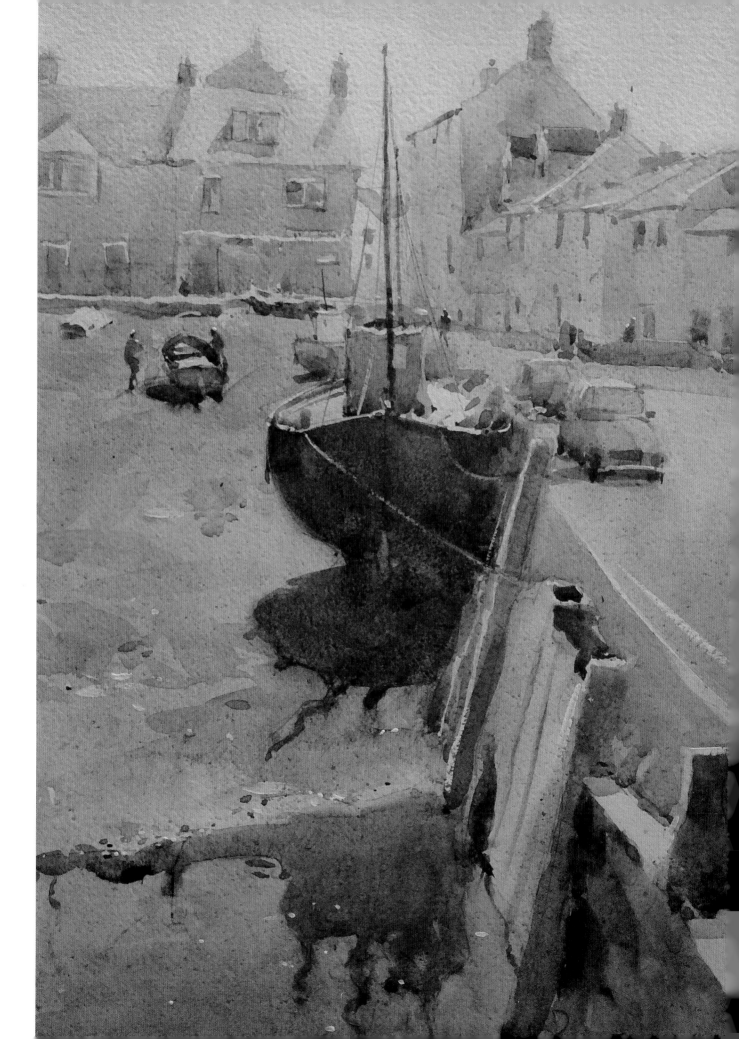

2. Travelling light

Because time is precious when painting on location, you want to be able to work as efficiently and effectively as possible, and this means having just the right amount and the right type of equipment with you. Travelling light is best: you don't want to be weighed down with unnecessary gear or have to waste time searching for things. Remember, you will be working on a smaller scale than you would normally choose in the studio, and similarly the technique will be different – essentially an *alla prima*, 'one-hit' technique (applying the correct colours straight away, without any underpainting or further modification). So you want equipment that will aid that process. For me, that means a limited palette of colours; short-hair, springy brushes; either stretched paper or a watercolour block, for working in watercolour; and prepared boards that are not too dry or too slippery, or small stretched canvases, for oil painting.

Opposite *Gairloch Harbour*
Watercolour on Two Rivers tinted paper
38.5 x 28.5cm (15¼ x 11¼in)
Finding the best viewpoint from which to paint a subject can make all the difference. Here, I wanted an interesting combination of background, solid middleground interest, and foreground reflections – which I thought would best suit a portrait format.

Equipment

I have now devised a way of carrying a reasonably lightweight selection of materials for both oils and watercolour. I prefer to have both media available because I can never be quite sure, until I arrive at a location, what I am going to find in the way of subject matter and conditions. In hot, sultry conditions I prefer to work in oils, while cooler, bright conditions suggest watercolours – allowing washes to dry steadily, rather than too fast or, in a damp atmosphere, perhaps not drying at all. Usually, I take a selection of equipment in a rucksack that has an attached folding stool. I have one rucksack for oil-painting equipment and another for watercolours. Additionally, I usually carry a lightweight folding easel.

Basic materials

It takes time and experience to find the materials that work best for you, and it is also a matter of trial and error. If, for example, the particular texture or absorbency of the watercolour paper you are using prevents you from achieving certain effects, experiment with a different paper.

Above My Craig Young watercolour palette, which is a modern-day version of the classic Binning Munro palette, with paints and mixing wells in one convenient metal box.

Right My oil-painting rucksack, with its attached folding stool.

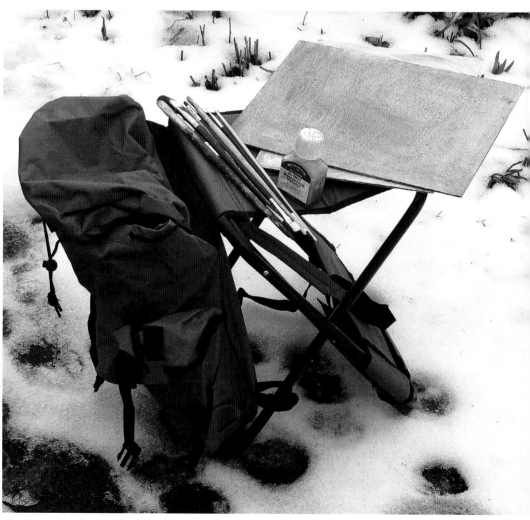

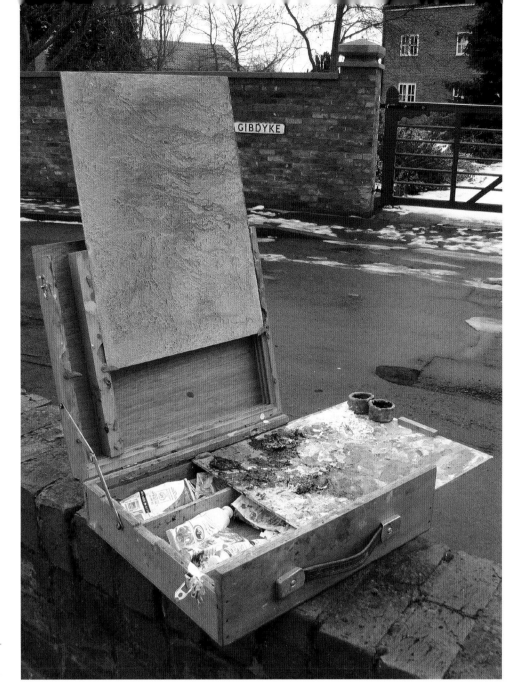

Over many years of painting *en plein air*, I have discovered that the surface I prefer for watercolour painting is stretched Arches 640gsm (300lb) Rough or Two Rivers tinted paper – particularly so if there is time to work on a larger scale than usual. So for outdoors, I normally choose paper of approximately A3 size (297 × 420mm/11½ × 16in), but if conditions are right I do occasionally work at almost twice this size. The Arches paper is thick and robust. It will take generous washes and stand up to quite vigorous treatment. I also like to use Saunders Waterford blocks. These are blocks of paper gummed on all four sides so that the paper doesn't need stretching. Various sizes are available.

The colours I use for watercolour painting are cobalt green, viridian, French ultramarine, cerulean blue, cobalt blue, cobalt violet, raw sienna, permanent rose, aureolin, Winsor lemon, gamboge, burnt sienna and vermilion. These are tube colours, which I squeeze out to fill the compartments in my watercolour palette.

For both watercolours and oils I prefer short-haired brushes, because these have more 'spring'. My watercolour brushes are mostly Kolinsky sables, sizes 8, 10, 12 and 14, but

Above The lightweight sketching easel fitted with the easel 'stays' that will hold a pochade box.

Above right *The Stand of Trees, Little Barrington* Location photograph.

I also have some sable/synthetic-mix brushes. I carry a selection of brushes in a protective brush pack. Similarly, for oils, I like a mixture of natural-hair bright bristle brushes, sizes 1 to 14, and some synthetic-hair short, flat brushes, which I find are extremely good for adding rigging lines and other details.

I now include more yellows in my oil-painting colour palette than previously. This is something that has changed over the years, as I have developed a better understanding of which colours suit the colour mixes required for my preferred *plein-air* subjects. My colours are titanium white, cadmium orange, permanent rose, cobalt violet, viridian hue (students' quality), viridian (artists' quality), terre verte, cerulean, French ultramarine, raw sienna, Indian yellow, burnt sienna, Winsor lemon, buff titanium, Naples yellow and Naples yellow light.

Outside, I usually paint on small hardboard panels, generally no larger than 30.5 × 40.5cm (12 × 16in), which my framer makes to suit my requirements. I use the smooth side of the board and this is prepared first with a coat of acrylic primer, then with a coat of gesso primer and texture paste mixed together. I vary the proportion of this mixture, so that some boards have more texture than others. Then, to ensure a dense, white finish, I add a further coat of gesso primer and let the boards dry.

Most of the boards are painted with a neutral coloured turpsy wash (paint mixed with a generous amount of turpentine), some with a warm-toned wash (French ultramarine, raw sienna and burnt sienna), and some with a cool, neutral-toned wash (French ultramarine and raw sienna). This gives me a choice of surface textures and colours for different subjects, and I also have some white boards for the subjects that I think will work better with a 'rub-out' technique (see pages 87–88). Also, sometimes I take a small canvas to work on, or a canvas board.

I have painted in oils and watercolour for most of my career – the two media complement each other perfectly, I think. However, for almost a year, right at the beginning of my career, I concentrated mainly on working in pastels. This is a beautiful medium and

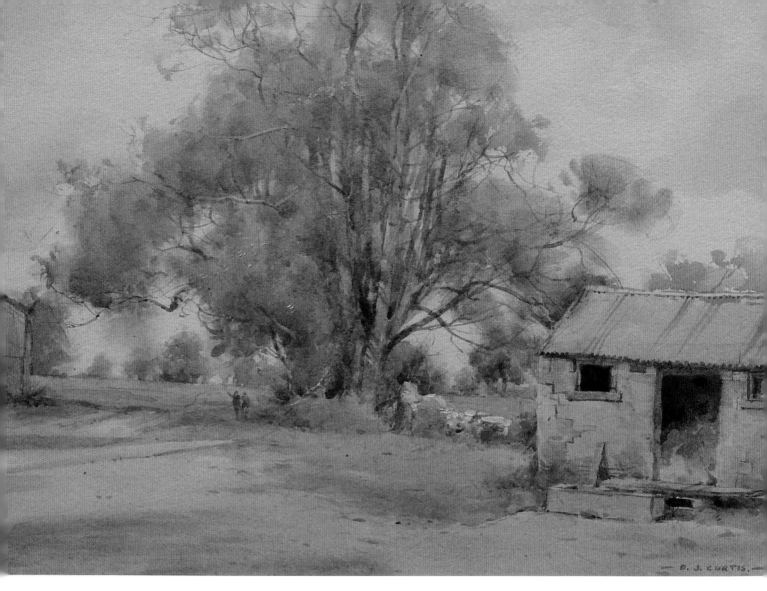

Above *The Stand of Trees, Little Barrington*
Watercolour on Two Rivers tinted paper
28.5 x 38.5cm (11¼ x 15¼in)
Sometimes the subject matter has very limited appeal (see the photograph opposite). Yet with some imagination and prudent selection and emphasis, it can still provide the basis for a successful painting.

one that I can strongly recommend for location work. The essence of pastel painting is that you place the right tone straight away, rather than rely on colour-mixing on the paper. If you rub colours together or overlay colours to any great extent, you lose the crispness and vibrancy of the work. Lay and lift – that is the secret of the pastel technique. Consequently, you need a large range of colours. I used to have a palette of between 80 and 120 colours kept in various compartments within a pastel box.

Whatever medium you decide to use, my advice is to buy the best quality that you can afford. This particularly applies to the support (surface) that you choose to work on, and the brushes. For example, a fine-quality sable brush, although expensive, will always prove a good investment. It will respond sensitively to different handling techniques and, if well looked after, will last a very long time.

Easels and other equipment

Generally, I prefer to stand and paint, particularly for watercolour, so I either use my wooden sketching easel, which I have had for the past 40 years (a Winsor & Newton Perfect Easel), or my box easel. (It isn't essential to stand, of course. Some artists prefer to sit on the ground or on a stool, working at a board propped up on their knees, or they might find a low wall, a tree stump or something else to sit on.) The box easel is sturdy, will hold all the equipment I need, and enables me to tackle paintings up to 51 × 61cm (20 × 24in).

It is fine if I can work near the car, but not ideal if I have to walk any distance, as it is surprisingly heavy.

In fact, more often now I prefer to take the lightweight sketching easel with me, rather than the box easel. It is perfect for watercolours because I can fix the board at an angle of about 30–40°; it also works well, used in combination with a pochade box, for painting in oils. Then, I use the easel stays, which attach to the legs of the easel, to hold the box in place – see the photograph on page 32. I have several pochade boxes of different sizes, starting with a small (15 × 20cm/ 6 × 8in) pocket-sized box. A pochade box is essentially a small wooden box with compartments for paints, brushes and other materials, including several boards, which fit into the lid.

First impressions

Having arrived at a location, arguably the most important decision you will have to make is the choice of subject matter. Ideally, you need to find a subject that excites you, is a bit of a challenge, and works well in terms of composition and tonal values. You may need to spend a little time looking around and getting a feel for the location and what it has to offer, but in my view it is best not to spend too long on this. Rarely will you come across a subject that is perfect as it stands. Often, the real creativity lies in extracting the most potential from a subject that is not ideal in itself but is the best available. The subject will have some elements you can build on, but equally you will need to put your skill and inventiveness to the test to make the best of what you see.

The Stand of Trees, Little Barrington (page 33) is a good example of a successful painting developed from subject matter that in reality was fairly uninspiring – see the photograph on page 32. It was a subject that wouldn't normally get a second glance, yet I could see that there was potential there, providing I made a few adjustments to the composition and colour values. Obviously I decided to leave out the ugly power cables and poles behind the barn on the right. It needed something to soften the line of the barn roof, so I introduced more trees there. In fact, while I was painting, the sun came out a little, and this lifted and warmed the colour throughout the scene, especially on the large tree. Additionally, I enhanced the sense of space by making the distant trees more diffused, and I added the two figures to create a point of interest. So essentially the emphasis was on the paint and the technique – making the paint speak more than the subject.

Travelling abroad

For me, one of the advantages of travelling abroad is the stimulus of new, exciting and very different types of subject matter. Equally, I like the contrast in colour and atmosphere when painting in countries such as Spain and Italy. Generally, these places are warmer and more comfortable for *plein-air* work and, because the sun is high and the shadows are slow-moving, there is the potential to spend more time on each painting.

However, usually there are more people about, especially in the tourist hotspots, and this means that someone painting is likely to attract inquisitive onlookers. It is something you get used to. Nevertheless, whenever I can, I try to find a doorway or I work with my back against a wall, so that it is not so easy for people to watch and interrupt me. For *Café Study*,

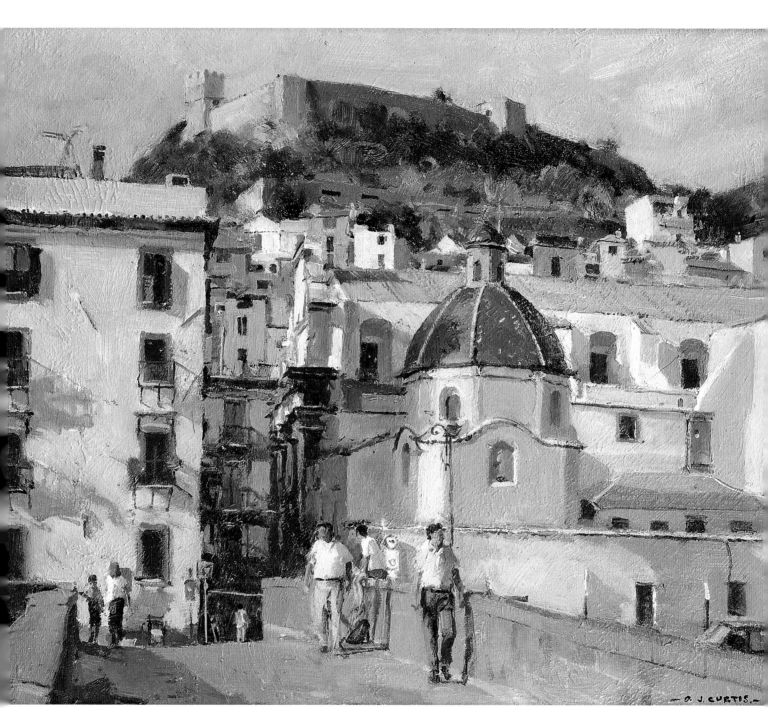

Above *The Bridge over the River, Bosa, Sardinia*
Oil on board
25.5 x 30.5 cm (10 x 12 in)
For this painting, I managed to tuck myself away
in a corner of the bridge so that I wouldn't attract
too much attention! It was a lovely architectural
subject, enhanced by the strong lead-in of the
bridge itself.

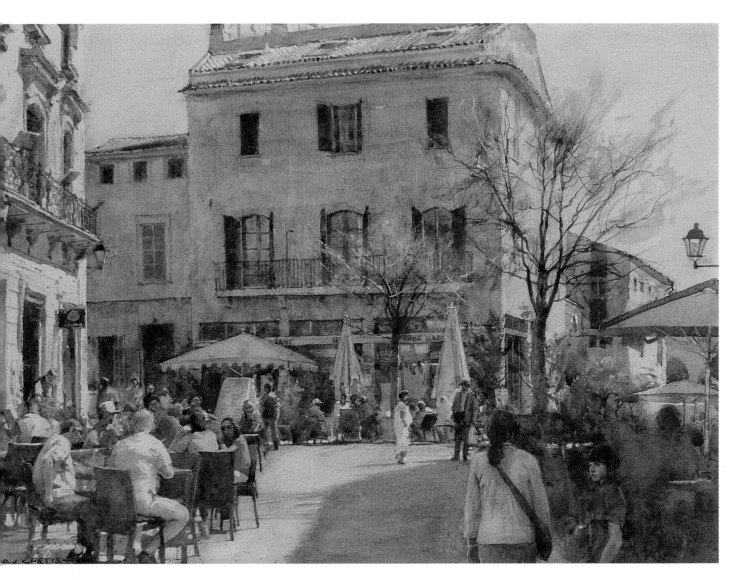

Above *Café Study, Alcúdia, Mallorca*
Watercolour on Arches Rough paper
28.5 x 38.5cm (11¼ x 15¼in)
Here, I chose a low viewpoint to make the most of the reflected light on the roof of the central building. Most of the painting was produced on site, although I added some of the figures later, from photographic references.

Opposite *Café Study, off Las Ramblas, Barcelona*
Oil on board
30.5 x 25.5cm (12 x 10in)
Here again, to achieve a really successful painting, much depended on what was included and what was left out. I decided not to include the whole of the second arch, as it would have made the composition too balanced.

off Las Ramblas, Barcelona (opposite), for example, I managed to tuck myself into a corner, away from the crowds, so that I could work quickly to capture the sense of movement and atmosphere of the scene.

As for all mry *plein-air* work, when I am travelling abroad I prefer to have both oil painting and watercolour equipment with me. Essentially, I keep to the same colour palette, except that I usually add a few extra colours, such as yellow ochre and light red, to suit the terracotta buildings and other subjects that I might find. More recently, as a substitute for oil paints (because of the restrictions that now apply to carrying oil-painting materials on planes), I have used alkyd colours. Incidentally, when I paint abroad, usually my aim is for good reference material rather than finished work suitable for exhibition. Alkyd colours are ideal in this respect, because they dry much faster than oils.

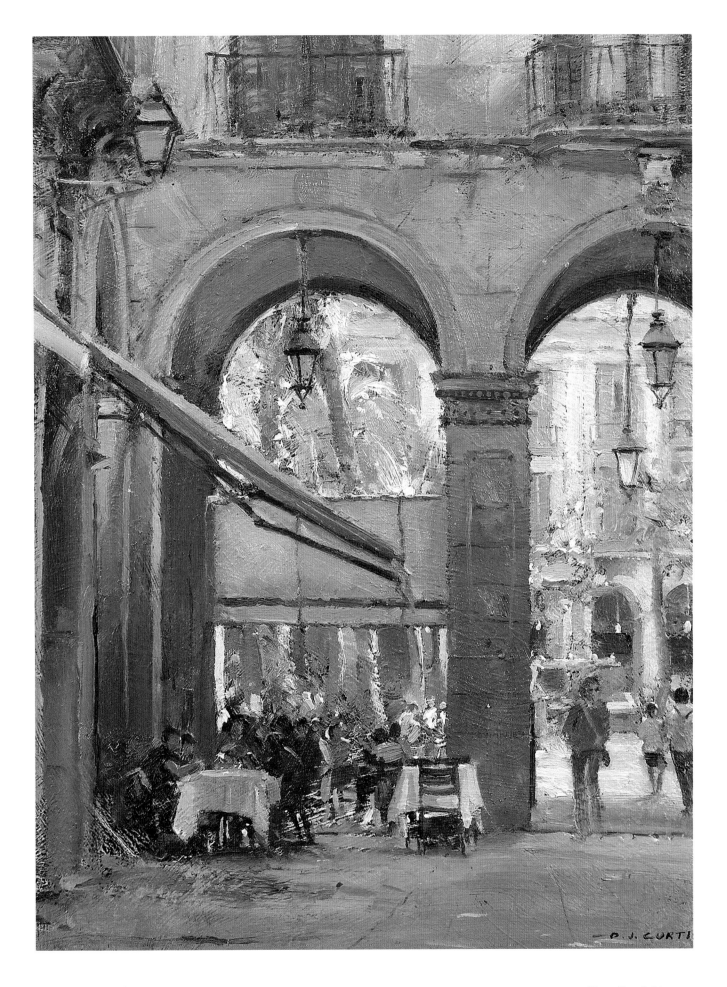

D. J. CURTIS

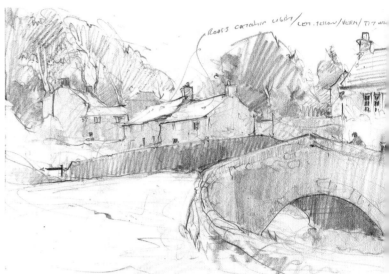

Above *Boulby Cliffs, Winter*
Pencil on cartridge paper
20.5 x 29cm (8 x 11½in)
Working on a sketch like this will give you a
good understanding of a subject before you
attempt a painting.

Above right *Packhorse Bridge, Yorkshire Dales*
Pencil on cartridge paper
13.5 x 21cm (5¼ x 8¼in)
If you are at a village location, for example, with
lots of painting possibilities, start with a few
quick sketches like this to test out different
compositions and ideas.

Right *Old Man Resting, Bubion*
Pencil on cartridge paper
20.5 x 28cm (8 x 11in)
This old man was an interesting subject to
sketch and I am sure that sooner or later he will
feature in one of my paintings.

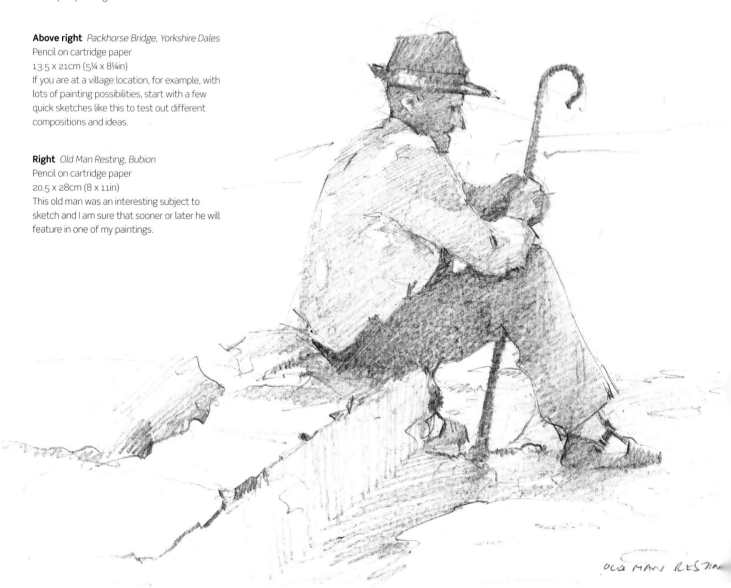

Location sketches

Like most artists, I take photographs when necessary: there are situations in which photographs are a very useful source of reference. But I still make sketches. I think it is a discipline that is essential for all artists. Where paintings are weak, often it is because the artist lacks drawing skills rather than painting skills. One way to improve and maintain drawing skills is to sketch regularly. And sketching is a great way to really observe a subject and discover what gives it interest and impact. Before I start painting, I often make a small sketch to help me fully understand the tonal values and composition of a subject. Sometimes I make a sketch with a soft pencil in a small sketchbook, or I might make a tiny sketch with a brush in a corner of my canvas or board, rubbing this out when I am ready to start work on the actual painting.

Also, there are times when I need to make a fairly resolved sketch, because it is going to be used as the main form of reference for a painting. In the sketch I will concentrate on the composition and the light effect that I want for the painting, perhaps adding a few written notes about colours or other important qualities – as in *Boulby Cliffs, Winter* (opposite), for example, which was the preparatory drawing for a 25.5 × 35.5cm (10 × 14in) oil painting. Similarly, making a sketch such as *Packhorse Bridge, Yorkshire Dales* (opposite) is a good way of recording potential painting subjects and the best viewpoints at a location. And figure studies, such as *Old Man Resting, Bubion* (opposite) are always useful. You can refer to them for ideas when you want to add a figure to a painting.

Above *Coastal Path, Moylegrove, Pembrokeshire*
Pencil and watercolour on cartridge paper
20.5 x 29cm (8 x 11½in)
There were so many possible painting subjects along this section of the Pembrokeshire coastal path that I had difficulty in deciding which view would work best. But when I saw this scene, I was immediately struck by its interesting arrangement of shapes and the dramatic play of light and dark. I used it as the preparatory sketch for the painting on page 74.

Receding Tide with Moored Vessel

As I have said on page 34, if your time is limited, often the best approach is to rely to some extent on your imagination and to make the most of whatever subject matter is available, rather than spend valuable time looking for the ideal subject. However, for locations near to home, or when you are staying somewhere for a reasonable length of time, you can afford to wait for the right subject and conditions. And of course sometimes you may be lucky and unexpectedly come across something really unusual and inspirational, as was the case here.

Boats are one of my favourite subjects, but I rarely find a boat as exciting as this beautiful old clinker-built vessel. As a bonus, the context and lighting were perfect. I particularly liked the interesting wheelhouse, the way the light caught the prow of the boat, and its consequent reflection in the water. Given the intricate structure of the boat and the lovely soft passages of colour throughout the subject, I felt it might work best as a watercolour rather than an oil painting, and I started with some very controlled drawing.

In fact, this painting involved three distinct stages of work. The first evening, I sat on the sea wall and made the drawing, which took about two hours. I also applied masking fluid to all the areas I needed to protect as highlights or white areas. During the second session, the following evening, I worked on the initial 'ghost', wet-into-wet washes of colour, adding some more resolved soft brushwork effects over these. Finally, back in the studio, I rubbed off all the masking fluid and worked on any further definition and details that I thought were necessary, including adding a figure. It was a very satisfying painting – one that I would now much rather keep than sell!

Right *Receding Tide with Moored Vessel*
Watercolour on Arches Rough paper
28.5 x 38.5cm (11¼ x 15¼in).

3. *Alla prima*

Whatever the subject matter, it is usually a certain quality of light that creates the drama and impact in a scene and will inspire me to paint it. As I have explained, I normally have both oil-painting and watercolour equipment with me when I am working on site, and this gives me the opportunity to choose whichever medium is best suited to the light, subject and conditions at the time. I think there is a great advantage in being able to work in more than one medium and I always advise aspiring painters to develop that choice if they can. In choosing a subject, one of the most important points to bear in mind is your level of ability, together with your knowledge and experience, so that you can make the most of what is there. I start by considering the overall impression of the subject in terms of shape, tone, colour and atmosphere. Generally, for an atmospheric landscape, which needs diffused colour effects with no hard edges, I will probably choose watercolour. But when there is greater definition, with stronger shapes and contrasting tones, I usually choose oils. However, there are no hard-and-fast rules. The way you feel on the day and your degree of confidence can be just as influential in choosing a particular medium and approach as other, more practical considerations.

Opposite *A Walkers' Path, Edale Valley*
Oil on board
40.5 x 30.5cm (16 x 12in)
This heaven-sent subject satisfied all the criteria that I look for when painting on location. Its appeal, composition and tonal interest were all just scintillating. I particularly liked the position of the cottage, with the dark area behind the gate and the figure, while the shape of the tree and the general sense of tonal counterchange were inspirational.

Wet on wet

A considerable proportion of my *plein-air* work is in oils. For me, oil paint is the perfect medium for capturing fleeting light effects with speed and control because it can be used very effectively with a 'one-hit' technique – essentially, applying the colours as finished colours, wet on wet, with very little overworking. I usually paint on prepared boards, and I have a variety of these boards available – white, textured and toned, giving me different options to suit the subject matter and the approach I want to use. Usually, my technique with oil colour is to start with blocky shapes and then work on whatever amount of firming up and detail is necessary.

Fishing Pond, Misson (below) is a good example of my quick, 'one-hit' oil-painting technique. I spotted this delightful, simple subject in some old quarry workings near my home, when I was out one day walking the dog. The scene was all about light, I felt. In particular, its attraction was the light on the water, but there was also a shimmering light on the trees, giving a sense of heat. The success of this small pochade-box painting relied on broad brushstrokes and the ability to place the right tones, without making anything too light or too dark.

Tonal impact

The overall tonal impact of the subject matter, the lost-and-found play of light and dark shapes, is something that must be considered right from the start. Often, in fact, it is the tonal key that initially attracts attention to a subject. Especially when painting in oils, the ability to assess tonal values, and consequently mix colours speedily and with the correct tonal shift, is vital to the success of the work. Given the time constraints and other factors inherent in painting outdoors, there isn't the scope to work with a succession of layers and glazes, as you might in the studio, when you can leave stages to dry. Therefore on site, as far as possible, the aim is to place the correct colour and tone straight away, ideally without any significant further modification or overpainting.

Below *Fishing Pond, Misson*
Oil on board
17.5 x 25.5cm (7 x 10in)
To capture the mood and atmosphere of this lovely, simple subject, I relied on broad brushstrokes, the 'one-hit' oil-painting technique, and conveying exactly the right tonal values.

Below right *Rising Water in the Beck*
Oil on board
25.5 x 30.5cm (10 x 12in)
Especially with a subject like this, in which the tide and light are changing all the time, it is vital that the design and tonal range are established as quickly as possible. Incidentally, I took a photograph of the boat and used this as reference for some additional work back in the studio. I do think that man-made objects should be well executed, and there isn't always time to do this on site.

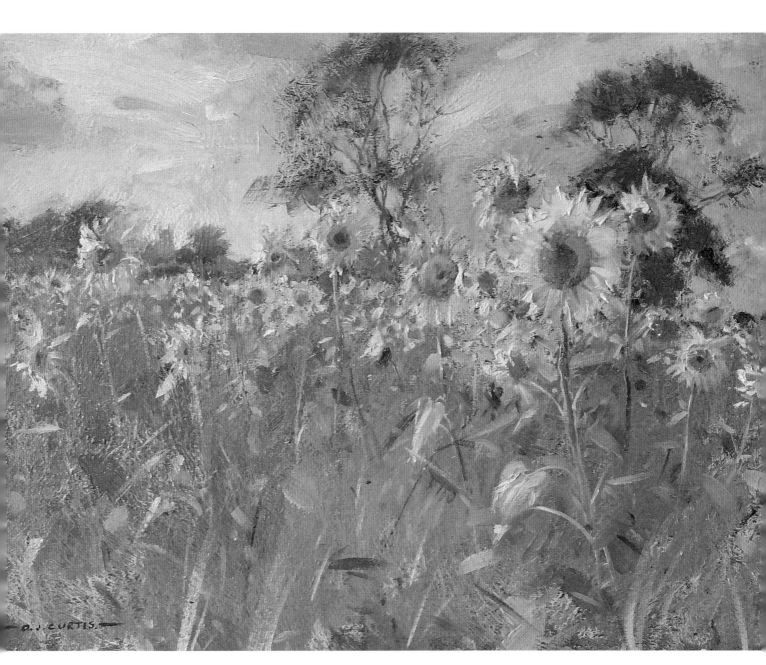

Rising Water in the Beck (opposite) was an absolutely knockout tonal subject. I painted this at Easter time, in misty conditions, with a gently rising tide. The mood was quiet, calm and rather mysterious, and this created subtle mid-tones almost throughout the whole subject, the only significant dark area being the reflection of the boat. I didn't include any sky – I liked the way the sky was suggested by virtue of its reflection in the foreground water. I used the nicely angled, lonely little boat as the focal point for the composition, and this was the only part that I needed to do some further work on back in the studio. It was important that the boat was carefully executed and gave substance and reality to the scene.

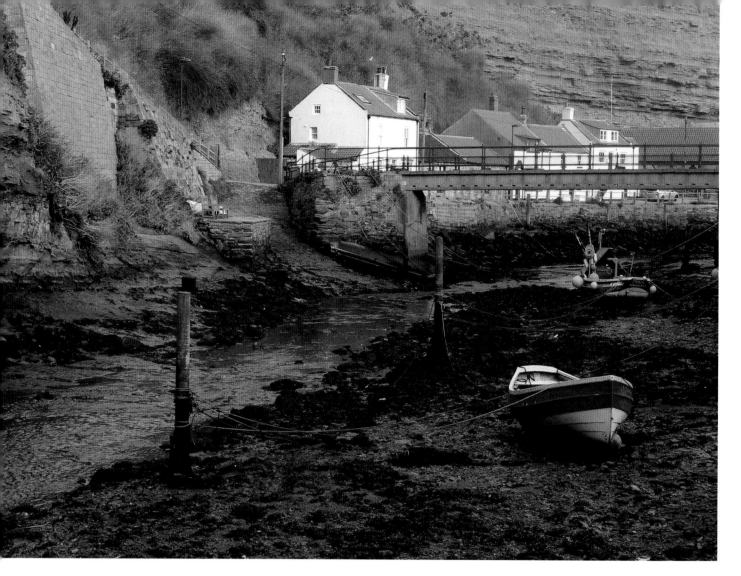

Key shapes

Shape is a crucial factor to consider, both in the choice of subject matter and throughout the painting process. Look for subjects that offer a sound, interesting structure of fairly simple shapes that won't need a lot of modification to make them work as a successful composition, bearing in mind the time available. *Morning Sun in the Beck* (pages 47–49) demonstrates my working process for *plein-air* oil painting and the emphasis I place on shape and tone.

With *Morning Sun in the Beck* it was the effect of the light as much as anything that inspired me to paint the scene. Fortunately, it is a location that I know well, and from experience I know that the light can change quite quickly. So I realized that I must block in the main background tones as soon as possible – those either side of the large cottage, as well as the important highlight on the cottage itself. You can see in Stage 1 (opposite) how I began with this area, having first made a quick brush drawing to indicate the boat, posts and other main elements. Note also that I have placed the darkest dark at the back of the cottage, thus giving me the two extremes of tonal reference.

Above *Stage 1*
With a worn bristle brush, I made a quick drawing and blocked in the general background tones, including the key light and dark tones.

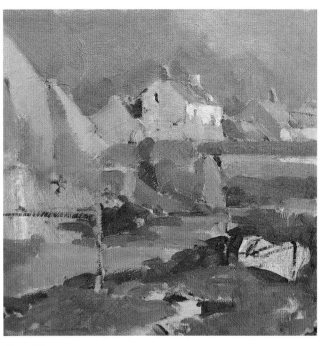

Above *Stage 2*
Next, I focused on the foreground area, placing the main tonal values relative to those already stated.

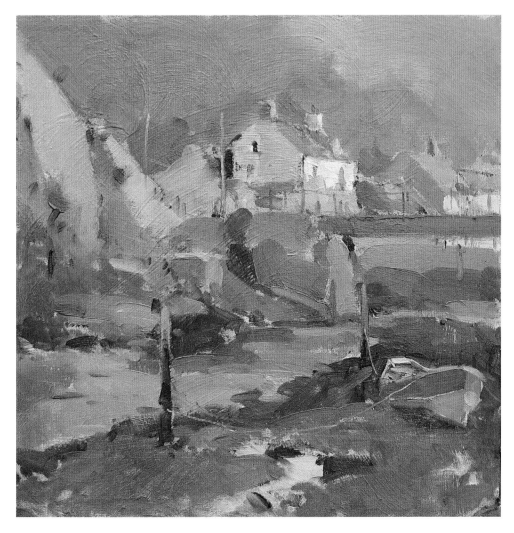

Left *Stage 3*
By addressing the boat and doing some more work on the far side of the river, I now had all the important blocking-in foundational work in place.

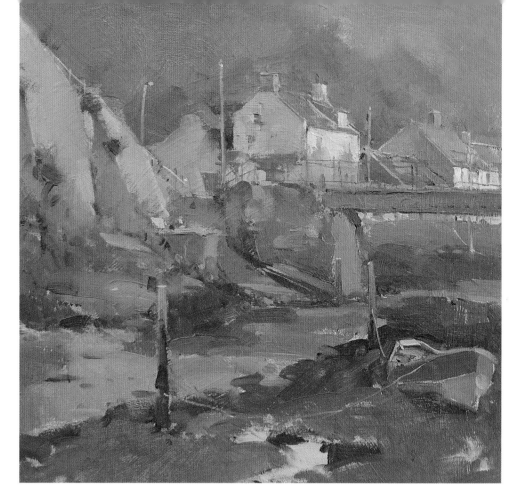

Again, I decided not to include any sky in this painting, but instead made the most of the reflected light in the foreground water left at low tide. In fact, I moved one or two of these patches of water into the picture area to add more foreground interest – as you can see, they do not show in the location photograph (page 46). I chose a 25.5 × 25.5cm (10 × 10in) dry board for this painting, which had been prepared with a scrubbed-in wash made from a mixture of French ultramarine and burnt sienna.

Next, having set the main shapes and tones for the top half of the painting, I needed to work on the foreground area, Stage 2 (page 47), assessing the tones relative to those already stated and aiming to make sense of the reflected light on the water. In Stage 3 (page 47), you can see that I addressed the boat and did some more work to the left of the river. I also added a little more information to the gable end of the main cottage, plus one or two useful verticals. At this point the whole board was covered. Everything was registered correctly: all the important hard work was in place.

Those first three stages are always critical. Having created a sound foundation for the painting, I then moved on to the 'fun' part. Essentially, this involves firming up shapes and emphasizing lights and darks where necessary. In Stage 4 (above), I firmed up the line of buildings and added a little more definition to the background hillside and the structure of the bridge. Finally (see *Morning Sun in the Beck*, opposite), my focus was on the water, adding more interest to the surface with horizontal, defining brushstrokes applied with a dragged, light touch. Because I work with a short bright brush (a No. 2 or a No. 3) and the paintbrush is never fully loaded, it is possible to use a certain amount of wet-on-wet technique. I sharpened up the foreground and emphasized some of the darks.

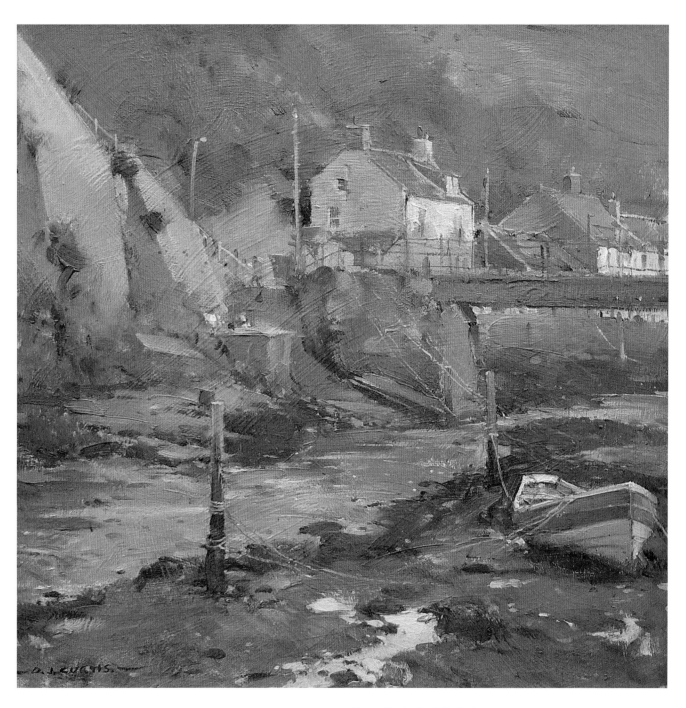

Above *Morning Sun in the Beck*
Oil on board
25.5 x 25.5cm (10 x 10in)
Finally, I added more detail and emphasis
to the foreground.

Freedom and control

Watercolour is usually my choice for subjects in which there is a great sense of atmosphere and in which accuracy in depicting the shapes isn't quite so vital – for example, when I am painting in the Lake District. However, as I have mentioned with regard to oils, the weather conditions, the timescale, the complexity of the drawing, the subject appeal, and one's mindset on the day also play a part in determining the choice of medium. On balance, though, watercolour needs more confidence, I think. As Edward Wesson used to say: 'Four out of ten if you are lucky!' Most watercolours will be satisfactory but, in my view, it is rarely easy to paint the real gems on location.

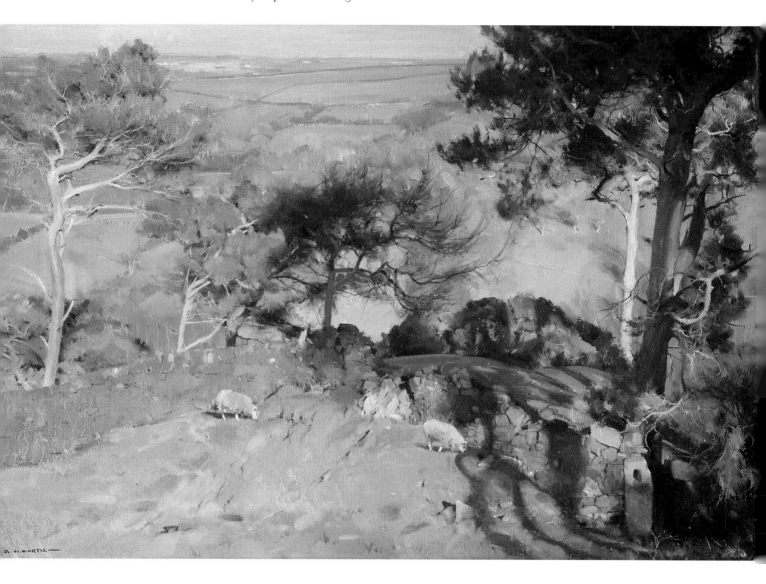

Above *Windswept Pines Above Sleights*
Oil on canvas
76 x 51cm (30 x 20in)
This painting was produced largely from two earlier pochade-box studies. Note how there are contrasting soft and hard-edged strokes, to create a sense of rhythm and visual flow to the piece.

Above *Cottages on the Rise to Cowbar, Staithes*
Watercolour on Arches Rough paper 38.5 x 57cm (15¼ x 22½in)
This painting is a good demonstration of my *plein-air* watercolour-painting technique. I started with a drawing, followed by the discreet use of masking fluid to reserve the highlights, then the important, general 'ghost' wash, and finally the use of crisper marks and washes for detail and definition.

Initial drawing

When I work in watercolour I always start with a pencil drawing, and I use this as a guide throughout the painting process. I concentrate on scale and proportion, using the side of the pencil and keeping the drawing lively by moving from the wrist and shoulder. I want the drawing to have a rhythm, a flowing freedom that will subsequently follow through in the initial 'ghost' wash and the rest of the painting. The drawing is made with a 3B or 4B pencil, and because I always work on good-quality watercolour paper, it isn't difficult to lift marks out with a putty rubber if I need to make alterations. In any case, at the end of painting I usually rub out most of the drawing. What is important, I think, is being able to draw quickly and to keep the drawing lively. Look at the drawing for Barn Interior, Bilham House Farm on page 54, and notice how vital it is for the success of the painting.

The 'ghost' wash

After the drawing I consider which areas I need to protect with masking fluid (the extreme lights and perhaps some specific details) and then, once the masking fluid has been placed satisfactorily in terms of the design, I work on the 'ghost' wash. This initial, overall variegated wash is fundamental to the success of a painting. It is equivalent to the blocking-in stage of a *plein-air* oil painting. If the ghost wash is successful in laying the foundations for a convincing interpretation of a subject, I can be confident that the rest of the painting will work out equally well – I am 60 per cent there!

But a ghost wash demands speed and confidence, and requires a clear appreciation of the subject matter and the generalized tonal values. You must be well prepared: I start by mixing washes, in separate wells, of all my 'quiet' colours: cobalt blue, raw sienna, viridian and cobalt violet. Then, with a No. 12 or No. 14 sable brush and the stretched paper positioned at about a 30° angle, I apply a transitional wash from top to bottom across the painting. My aim is for a concise, soft wash that sets the scene, capturing the overall sense and mood of the subject.

As I apply the wash, I dip into the different colours, so that all the time I am adjusting, warming and cooling to meet the changes of colour and tonal value within the subject. Applying paint wet into wet is intense work – aiming to cover the whole surface before anything dries, but perhaps punching in one or two really dark tones (with a mixture of burnt sienna and French ultramarine) while the paint is just starting to dry. I want everything to look soft-edged at this stage. Later, I can superimpose further washes and, as necessary, add shadows, greater definition and detail. An important point to remember about the ghost wash is to make it stronger in tone than you think it ought to be. This is because a lot of the wash will drain off during the painting process, and in any case watercolour always dries to a lighter shade.

For *Cottages on the Rise to Cowbar* (page 51), after masking out the boat and the gable end of the cottage with masking fluid, I started with a big, flooded-in wash. Then, with a drier brush, I quickly lifted out the two diamond shapes of the sea wall, so that just a stain of that first wash remained. After that, I worked with much crisper brush effects to convey the different surface textures and more specific points of interest. In contrast, for *Cottages in Sunlight* (opposite), for which I chose a tinted paper to suit the warmth of the subject, I kept the initial ghost wash really watery and then, when it was dry, worked over it with a controlled bluish wash for the water and to firm everything up.

Opposite *Cottages in Sunlight*
Watercolour on Two Rivers tinted paper
35.5 x 28.5cm (14 x 11¼in)
This was a little experimental watercolour on tinted paper, working from an oil painting as reference. My aim was to use the tone of the paper as the basic source of the mood and light for the painting.

Descriptive washes

I love painting old barns and the more traditional farmyard subjects, with their jumble of interesting artefacts and machinery, although they are increasingly hard to find these days. With a subject like *Barn Interior, Bilham House Farm* (page 57), I am in my element!

In fact, as you can see from the photograph on the left, I decided to add more items to the barn's interior because I felt that this focal area of the painting needed greater impact. I used another painting as the reference for this. I chose a tinted, biscuit-coloured paper to work on, which I felt would suit the overall colouring and mood of the subject. Stage 1 (below) shows the drawing – a careful drawing, but not overly stated. Notice how, to devise the most effective composition, I have moved the archway off-centre, used just part of the doorway on the right as a 'stopper', and made the most of all the interesting features on the left-hand side.

I applied masking fluid to the window area and for one or two small highlights, and then worked on the 'ghost' wash, Stage 2 (opposite). This wash was quite blue at the top, but it also included pure yellow ochre on the right-hand side and in other areas French ultramarine, cobalt, burnt sienna and raw sienna, all mixed in and chopped and changed to suit the different surface tones and effects. Just before the wash was dry, I took a No. 8 sable brush and added the extreme dark tones – for example, for the sweeping dark stroke down the right-hand side, which stops the eye drifting out of the painting.

Below *Barn Interior, Bilham House Farm*
Location photograph.

Right *Stage 1*
It is important to start with a sound, competent drawing, which will act as a guide throughout the painting. As well as stating the composition quite clearly, the drawing should be lively and begin to instil a certain rhythm and energy into the work.

Opposite above *Stage 2*
For the 'ghost' wash I used French ultramarine, cobalt blue, burnt sienna, raw sienna and yellow ochre, working wet into wet and chopping and changing to suit the different tones and surface effects.

Opposite below *Stage 3*
Next, I rubbed off the masking fluid.

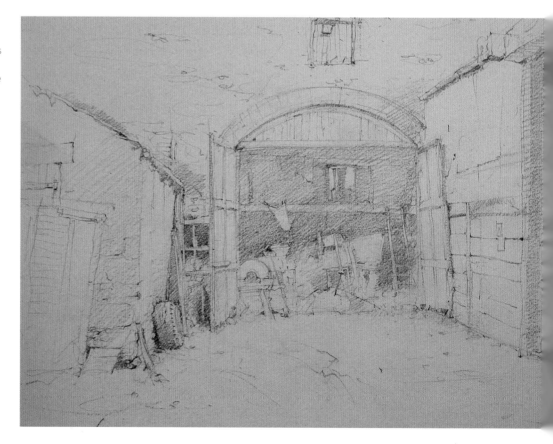

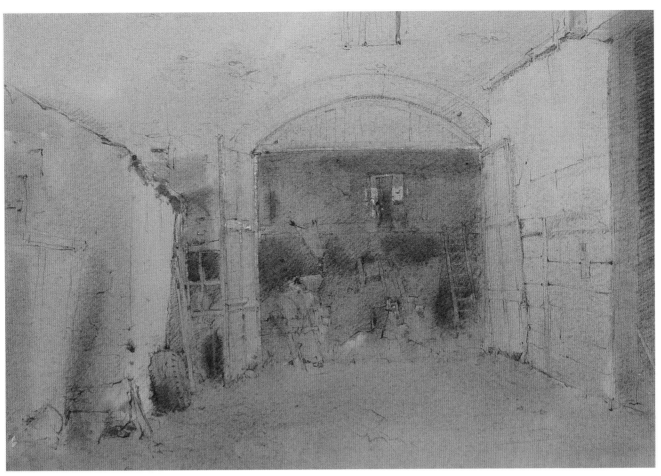

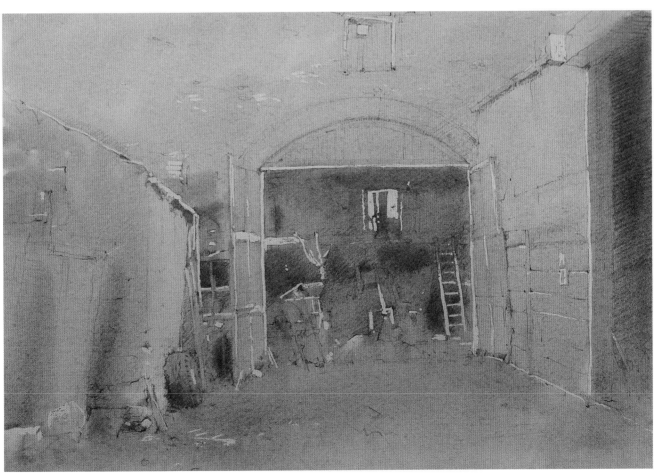

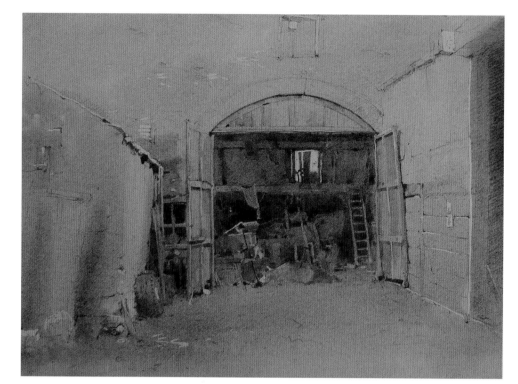

Right *Stage 4*
Then I concentrated on the darks and definition in the central area of the painting.

Below *Stage 5*
With a No. 4 sable/synthetic brush, moving to the side areas, I continued to firm up the shapes and add a few finishing details.

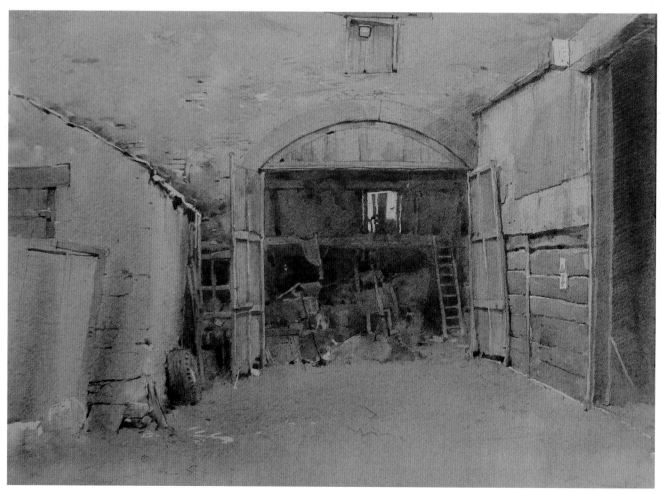

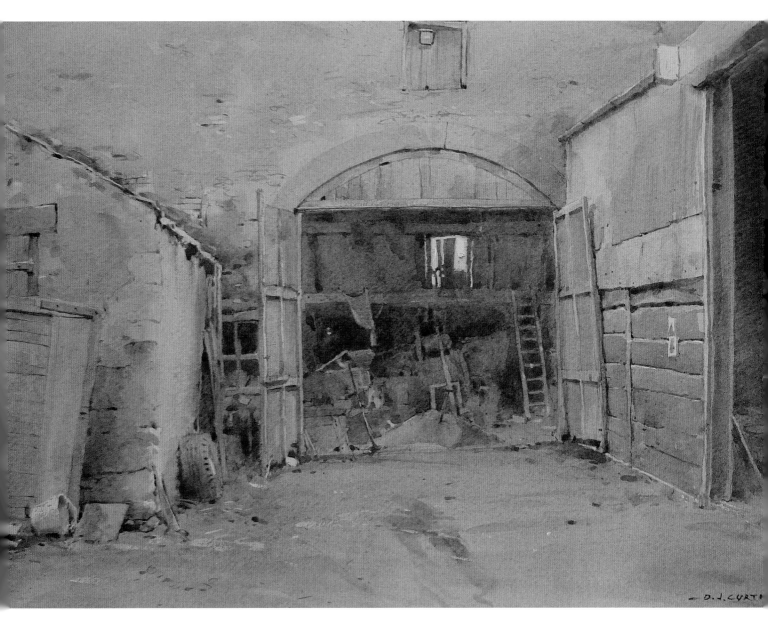

Above *Barn Interior, Bilham House Farm*
Watercolour on Two Rivers tinted paper
28.5 x 38.5cm (11¼ x 15¼in)
Finally, I worked on the foreground area and I rubbed out all the original pencil lines that were showing.

Next, I removed the masking fluid, Stage 3 (page 55), and slightly darkened the top of the archway. Then, in Stage 4 (opposite), I worked on the darks under the archway and began to define the various objects within the barn. This process continued in Stage 5 (opposite); where, mostly with a No. 4 sable/synthetic-mix brush, I was concentrating on the drawing, on bringing out the form and detail where necessary.

To complete the painting, *Barn Interior, Bilham House Farm* (above), I worked on the foreground area, adding touches of interest that also help lead the eye into the central part of the painting. I enhanced the light in the window, with a touch of titanium white acrylic paint mixed with cobalt blue, and finally I rubbed out the drawing. The key to success with this type of *plein-air* watercolour is, I think, knowing when to leave well alone. The less you need to modify or add to the ghost wash, the better.

4. Capturing the essence

There are times when it is possible to return to a subject on successive days and so, if you wish, have the opportunity to work at a larger scale and in more detail. However, usually *plein-air* painting means working with a sense of immediacy, employing an economical but expressive technique, and aiming to capture the essence of a subject in a single session. Indeed, especially when working in oils, *plein-air* paintings are generally characterized by the use of vigorous, raw brushstrokes and the obvious surface quality of the paint, and this adds to their impact. When paintings are more 'worked', they tend to lose that sense of vigour and consequently are often less interesting and appealing.

Occasionally, a change in the weather or some other unforeseen factor can limit the amount of work done on site, and then the only option is to finish the painting back in the studio. When this happens, the best approach is to continue with the painting as soon as you can, while the *plein-air* experience is still fresh in your mind, aiming to keep the immediacy and emotive quality of the initial work. Similarly, sometimes there are inspirational but rather complicated subjects which cannot satisfactorily be tackled on site, and in that case the solution is to make sketches, take photographs and collect as much information as you can about the subject while you are there, so creating a useful bank of reference material for a studio painting later on.

Midday Crowds, Siena (opposite) is an example of the combined *plein-air* and studio approach. I had been painting all day at that location, using my pochade box and working in oils on small, prepared boards. Then I thought I would like to try a large watercolour involving a slightly risky composition looking down an alleyway, from dark to light. The subject was far too complex to attempt on site, so I decided to use the small oil studies as reference, plus some photographs, and work on the painting when I returned to my studio.

Opposite *Midday Crowds, Siena*
Watercolour on Arches Rough paper
57 x 38.5cm (22½ x 15¼in)
For an ambitious subject like this, the best plan is to collect as much reference material as you can on site and then work on the final painting in the studio.

Appeal

For me, composition comes first: there is no point in considering a subject if the composition isn't striking, original and offering plenty of potential. The composition isn't always perfect as seen – it may need a bit of tweaking, simplifying or exaggerating in places, but essentially it must be sound and create an exciting structure for a painting. Next, I look for interesting tonal values. Again, I might need to adjust these, but it will be the tonal values that create most of the drama and impact in the painting.

In conjunction with the composition and the tonal values, I consider the quality of the light and estimate how long it will last and whether that gives me enough time to complete the painting. Will the light improve or is it likely to get worse? Basically, it is a matter of planning ahead, assessing the subject and conditions, and deciding whether you are on to a winner or if it is a lost cause. If the light or weather looks unreliable, it might be better to modify your objectives and try something smaller or simpler.

Below *Dredger on the Esk, Whitby Harbour*
Watercolour on Arches Rough paper
38.5 x 57cm (15¼ x 22½in)
I always look for a stunning composition, and this subject certainly had that!

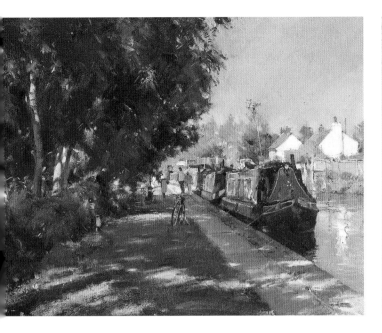

Above *Dappled Sunlight, Clayworth Wharf*
Oil on board
30.5 x 40.5cm (12 x 16in)
For this challenging subject, with its large tree mass and shadow area punctuated by flashes of light, I chose a rub-out technique. The board was prepared the night before with an initial lightly toned wash, and so it was still slightly wet when I used it the next day, allowing me to lift out the wash where I wanted highlights.

Above right *Fine Spring Morning, Jenkinsons' Farm, Clayworth*
Oil on board
30.5 x 40.5cm (12 x 16in)
By choosing a low viewpoint for this subject, I could create a more interesting composition and emphasize the lively character of the trees.

With *Dredger on the Esk, Whitby Harbour* (opposite) the attraction was the wonderful 'S' shaped composition, top-lit and including the fortuitous positioning of the moored dredger cutting into the space beneath the bridge. Without that, it would have been far less interesting. The strong composition was also what appealed to me about the shady towpath scene in *Dappled Sunlight, Clayworth Wharf* (above), although also in this subject I found the dramatic tonal interplay of dark against light shapes equally challenging and exciting. I particularly liked the diagonal lead-in feature of the towpath itself and the way the shadows of the trees, punctuated by flashes of light, added interest to the foreground area.

Viewpoint

Finding the right viewpoint from which to paint a subject can make all the difference between a painting that is only satisfactory and one that is more daring, creative and powerful. Particularly when you arrive at a new location, it is well worth spending some 'dither time' to search out the best subjects and viewpoints. I might spend perhaps 20 minutes or so walking to and fro to assess alternative viewpoints before making a decision, as I did for *Fine Spring Morning, Jenkinsons' Farm, Clayworth* (above), for example. It is surprising just how much the composition and impact of a subject can change if you move your position a few feet to the left or right, or adopt a slightly higher or lower viewpoint. An unusual viewpoint will add drama and interest to a composition, which is why I often choose a high or low viewpoint. I decided on a low viewpoint for *Fine Spring Morning, Jenkinsons' Farm, Clayworth*, because it helped to enhance the height and majestic character of the trees. It also allowed me to keep the little complex of farm buildings low-slung and so avoid creating a centre-line horizontal. It is an example of finding the optimal position to work from, and some thoughtful planning in this respect always pays dividends.

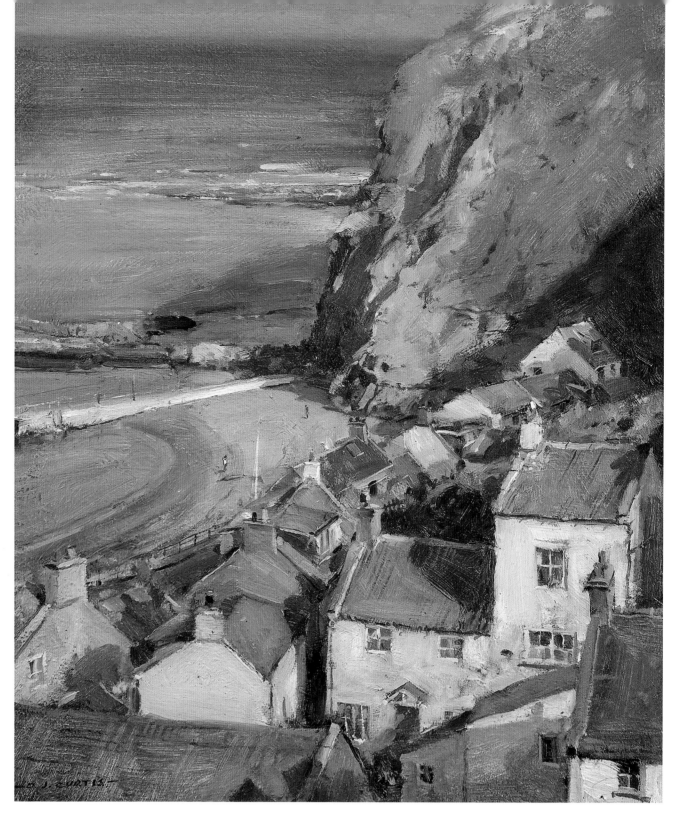

Above *High Viewpoint over Staithes Harbour*
Oil on board
30.5 x 25.5cm (12 x 10in)
It is always worth spending a little time walking around to find the best viewpoint and consequently the best composition, as I did here. A sound composition will inspire you with much more confidence.

In contrast, both *High Viewpoint over Staithes Harbour* (above) and *First Light and Cottage Rooftops* (opposite) have added drama because of the high viewpoint. Also, with both, it was a matter of having the discipline to select just the right area and amount from an extensive view. Some artists use a cardboard viewfinder to help 'frame' subjects and choose the best viewpoint, and looking through your camera's viewfinder will give a similar result. If there is time, you could test out different viewpoint options by making some quick, simple thumbnail sketches.

Strong design

When choosing a subject, I always think that if the composition is effective and inspirational, that is half the battle: a bold, original and interesting sense of design is essential in every painting. Whatever one's painting skill, if the composition is weak it will show and seriously undermine the success of the work. I look for subjects in which there is a strong, well-balanced arrangement of shapes and which also include lost-and-found passages that will enhance the feeling of space and form. I also look for the potential to make use of directional lines and features that will create a lead-in to the painting and add to the visual flow and rhythm within it.

Above *First Light and Cottage Rooftops*
Oil on board
20.5 x 30.5cm (8 x 12in)
Where there is a huge panoramic view, be selective. Home in on the most interesting and visually satisfying area.

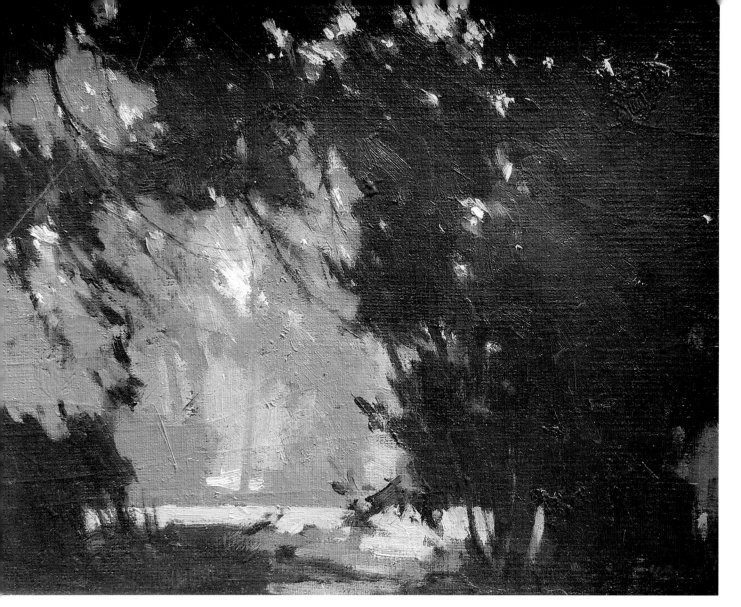

Above *Woodland Clearing*
Oil on canvas board
20.5 x 25.5cm (8 x 10in)
This was a lovely little cameo scene,
which I was delighted to find one
day as a diversion from working on
a rather unexciting commission to
paint someone's house!

Simplification

Some subjects are inherently simple and, as with *Woodland Clearing* (above), this can add to their effectiveness. A subject does not have to be complex and detailed to make a successful painting. In fact, too much emphasis on detail can be a distraction. You also need to judge whether the subject is a feasible proposition, given the time available. It should be challenging to a degree, but not impossible!

Ideally, what you hope to find is a subject that has plenty of interest and impact, but at the same time has the advantage of a dynamic composition comprising bold shapes. In assessing a subject, you need to decide which things are important and will contribute to capturing the essence of the scene, and which things can be simplified or perhaps left out altogether. A useful technique is to look at the subject through half-closed eyes. This helps you to focus on the main shapes and the key lights and darks. Remember, you need areas of rest in a painting as well as areas of interest.

Above *Boulby Top*
Oil on board
17.5 x 25.5cm (7 x 10in)
I painted this wonderfully
atmospheric scene from my car. In
bad weather, working from the car
can prove a good option, as can
painting from a doorway or looking
out from a suitably positioned
window in a house.

Right *After a Shower*
Watercolour on Arches Rough paper
19.5 x 28.5cm (7¾ x 11¼in)
The centre of interest in this painting
is the car, with various lines in the
foreground leading up to that point.

Right *High Aspect over the Beck, Staithes*
Oil on board
40.5 x 30.5cm (16 x 12in)
Note how, in this painting, everything leads to a focal point in the far distance, where the river disappears from view.

Opposite *Moorings, Whitby Harbour*
Oil on board
30.5 x 25.5cm (12 x 10in)
As here, sometimes a composition might rely on a main focal point (the half-shadowed wheelhouse of the boat) together with a supplementary focal point (the distant buildings at the end of the harbour wall).

Centre of interest

The more you paint outside, the quicker you become adept at noticing subjects that work compositionally. A good composition will give structure to a painting, create order and harmony, and ensure that when we look at the painting, our attention is directed around it and yet always kept within its bounds. Often in my paintings I have the focal point, the key feature of interest, fairly centrally placed – although never right in the centre – as with the car in *After a Shower* (page 65). Alternatively, I sometimes rely on the 'rule of thirds' principle (based on the Golden Section proportion), with the centre of interest positioned about one-third of the way across the picture area, as with the house at the end of the sea wall in *Moorings, Whitby Harbour* (opposite).

The focal point might be a special note of bold colour, a particularly strong highlight, or a figure or similar feature. I also look for a composition that will give me a lead-in feature and directional lines or linking features, such as shadows. Compositions with a Z-shape or S-shape work extremely well in this respect – see *Dredger on the Esk, Whitby Harbour* (page 60).

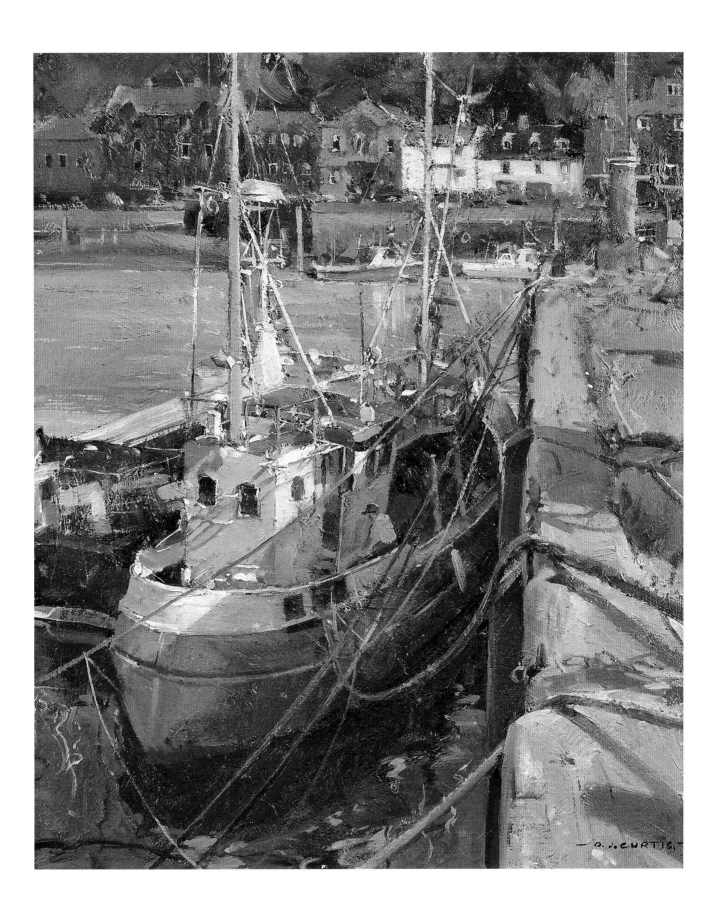

Above *Sheltered Bay near Puerto Pollensa, Mallorca*
Oil on board
20.5 x 30.5cm (8 x 12in)
Here is a subject full of the magic of light, with intriguing variations of tone and colour.

Light effects

When painting outdoors, you need to be sensitive to different light effects to see if they will work in your favour. These effects can vary enormously, of course, depending on the season, the particular time of day and the weather, creating tremendous scope for paintings of contrasting character and impact. However, a *plein-air* painter quickly learns that light can be very fickle: it can change dramatically within a very short length of time. One moment the sun might be shining and there will be wonderful shadows to include in your painting, but then the next moment the clouds bubble up and the sun and shadows disappear.

You have to be ready for this sort of situation and quickly decide whether the subject is more interesting in a flat light or when brightly lit. Usually, the best policy is to make a decision when you begin a painting and to stick with it. Rather than 'chase the light', try to establish the principal lights and darks, plus an indication of shadows, as quickly as you can. Then you are less likely to have a problem continuing in the same tonal key, should the light change.

Right *Matthew Fishing on a Bridge,*
Ardmaine Gardens
Oil on board
30.5 x 23cm (12 x 9in)
With the sun behind the trees, this
was very much a contre-jour subject
in which the main interest was
the play of subtle greens and the
glancing touches of sparkling light
here and there.

Contre-jour

With *contre-jour*, the subject is seen against the light, so the main shapes appear in
silhouette or partial silhouette. *Contre-jour* gives simplicity of shape, mystery in the shadow
areas, and usually low-key colour with high-key accents and details. It offers drama and
the chance to work quickly, making it a good option for *plein-air* work. It has attracted and
beguiled me for most of my painting life, although I am not so sure it is particularly kind
to the eyes. I now think that perhaps I shouldn't be looking into the sun quite as much and
increasingly I am choosing subjects that offer the more conventional, back-lit approach with
a greater emphasis on colour.

The beauty of *contre-jour* subjects is in their crispness and softness, where strong shapes
contrast with nuances of light and detail. This is demonstrated in *Matthew Fishing on a
Bridge, Ardmaine Gardens* (above), where the sun behind the trees creates a play of subtle
greens and flickering shafts of light. In fact, in this instance, the whole subject is fairly
middle-toned. On the other hand, *Sheltered Bay near Puerto Pollensa, Mallorca* (opposite) is

full of intriguing tonal and colour changes. This high-lit, *contre-jour* Continental subject is enhanced by the contrast between the warmth of colour in the foreground and the colour in the distance, which gradually cools off as it recedes.

Light and drama

Contre-jour light effects add drama to the subject and, similarly, this is why I also like painting in the early morning light and the late evening light. When the sun is low in the sky it creates wonderful shadow effects as well as strong foreground shapes. Look at *Last Light in the Beck* (above) for example. I thought this subject was incredibly powerful and exciting, the ultimate *contre-jour* subject. It looks like a simple subject, but in fact it was quite a challenging one and it needed a lot of discipline – the discipline to work the colour from warm to cool and to keep the edges soft, but if they were stated, to state them only where they were top-lit.

On a dull day with flat light there isn't the same drama of light and shade, although there is the advantage of a fairly consistent quality of light over a longer period of time. These conditions are ideal for subjects that do not rely so heavily on tonal contrasts but require more in the way of drawing and a considered approach – for me, barn interiors and boatyard workshops, for example.

For *Kettleness Point* (opposite), I started in more-or-less flat light, thinking I would paint the subject anyway, because of its great composition. But then, quite suddenly, the clouds dispersed, the sun came out, and what a revelation! As well as adding interesting shadows, it brought out all the nuances of colour, particularly in the different strata of the cliff face. Here was an instance (as I hadn't developed the painting very far) when I was able to change tack and take advantage of a better and more dramatic effect of the light.

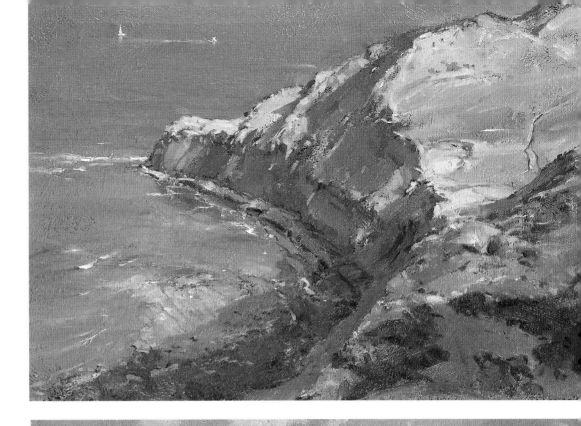

Above right *Kettleness Point*
Oil on board
23 x 30.5cm (9 x 12in)
I knew that I had found a great
composition here, but when the
sun came out and brought out all
the nuances of colour and tone, the
subject proved an absolute winner!

Right *Scudding Clouds Above
Harwell*
Oil on board
20.5 x 30.5cm (8 x 12in)
This was a glorious composition, with
a whole series of different textures
and wonderful lost-and-found
counterchange effects throughout.

Colour and mood

In my response to a subject I initially consider composition and tone, rather than colour. Nevertheless, colour is always important because it is descriptive and helps to personalize and bring out the character of a subject. Together with tone and technique, the chosen colour palette plays a key part in creating a certain mood for a work. However, I think you have to be careful not to overplay the use of colour: it must work in relation to everything else in the painting and not dominate in its impact, unless of course you decide to adopt a less representational approach.

I was surprisingly pleased with the mood and the warm harmony of colour that I managed to achieve in *Little Blue Boat on the Chesterfield Canal* (below), especially as I painted it without titanium white, which was missing from my pochade box. A senior moment, perhaps! My palette was buff titanium, Naples yellow light, Naples yellow, Winsor lemon, raw sienna, French ultramarine and cobalt violet. Naples yellow light is extremely light – a beautiful, gentle yellow – and in this case it proved a fine substitute for titanium white. Buff titanium is a lovely warm grey, while Naples yellow has a certain richness to it. These colours, mixed with cerulean blue, produce a wonderful range of quiet greens.

Below *Little Blue Boat on the Chesterfield Canal*
Oil on board
25.5 x 30.5cm (10 x 12in)
Having set everything up ready to start this painting, I found that I had no white paint available. Nevertheless, with the help of buff titanium, Naples yellow light and the rest of my 'quiet' colour palette, I was still able to create a lovely, warm colour harmony in this tranquil painting.

Right *Gale Force 8, Staithes Harbour*
Watercolour on Two Rivers tinted
paper
38.5 x 57cm (15¼ x 22½in)
Here, in fierce weather conditions,
I made some quick colour notes
on site as reference for making a
finished painting in the studio.

Below *Snowstorm 2011, Misson*
Watercolour on Two Rivers tinted
paper
38.5 x 45.5cm (15¼ x 18in)
Again here, the harsh weather (in this
case the extreme cold) prevented
me from painting entirely on site. But
with the advantage of working not
far from my studio, I managed to do
all the important initial wet-into-wet
washes on site.

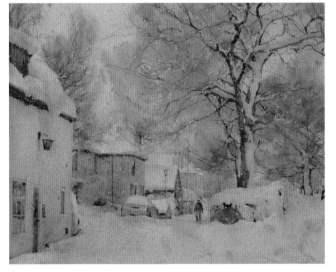

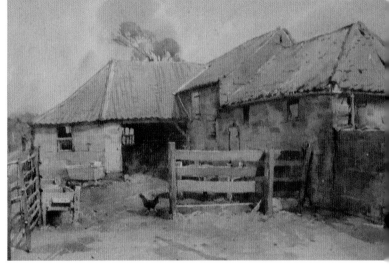

Above right *Old Gin Race,
Goldsborough Village*
Watercolour on Two Rivers off-white
paper
28.5 x 38.5cm (11¼ x 15¼in)
It is always best to keep to a fairly
limited colour palette for *plein-air*
work, although here I did choose
a slightly wider range of colours
than usual – including vermilion, for
example – to suit the more colourful
nature of the subject matter.

Colour palette

As a general guide for *plein-air* work, keep to a limited palette of perhaps five or six colours, selecting these to suit the subject matter and the overall effect you want to achieve. Within the subject matter, look for relationships of warm and cool colours, and colour harmonies, contrasts and counterchange. It is much more difficult to create harmony in a painting that includes a huge range of colours. There is always the temptation to use more colours than you need, especially if you have a wide choice available.

Colour can be subtle and subdued, of course, as well as bold and bright. For *Gale Force 8, Staithes Harbour* (above), to capture the dark mood of the storm, I chose a limited palette of French ultramarine, cobalt blue, raw sienna and cobalt violet. Because of the fierce weather conditions, I was limited to making colour sketches on site, and then I used these as the reference for the final painting, produced in the studio. It is a painting that relied very

much on thoughtful colour-mixing – mostly greys and purples, with some tiny accents of colour on the boats. In contrast, for the more colourful *Old Gin Race, Goldsborough Village* (page 73), I chose a wider palette of cobalt blue, vermilion, raw sienna, viridian, cerulean and cobalt violet, plus burnt sienna and French ultramarine for the innermost darks, which suited the subject and warmer lighting conditions.

A personal response

Although *plein-air* paintings are based on fact, on working from observation, this does not mean that you are confined simply to making a record of what is there. It isn't essential to be entirely truthful to a subject's content: you should never feel limited by a concern for accuracy. Quite often in a painting it is necessary to move things, leave things out or put things in, or to exaggerate or simplify, in order to make the most of the subject and create a result that has impact. Self-expression is fundamental to painting, so don't be afraid to focus on what you regard as important about the subject and to express this in your own distinctive way.

Similarly, in choosing subjects, respond to your own feelings and inspiration, rather than thinking that certain subjects will carry more weight and attract more interest from other people. For example, my painting of *Midwinter Reflections in the Pond, Gibdyke House* (opposite) is simply a corner of my garden. In one sense it is a painting of something quite ordinary. It is not Venice, Staithes or some other notable or popular subject. But for me, when I saw it on a particularly bright winter's afternoon, it just said 'Paint me!' It is a painting about light – the wonderful, warm light on the grasses and the shafts of light running across the water's surface. Equally, I liked the play of blue and gold complementary colours, which I think is always a great and exciting combination.

Below left *Coastal Path, Moylegrove, Pembrokeshire*
Oil on board
25.5 x 35.5cm (10 x 14in)
I loved the opportunity to observe and capture the different textures and variations in the complex rock structures here.

Below right *Bridge Across the Tiber, Rome*
Watercolour on Arches Rough paper
38 x 57cm (15 x 22½in)
When travelling abroad, there isn't always time at each location to paint everything that you would like to. So, as I did here, make some detailed studies and take some photographs for later reference.

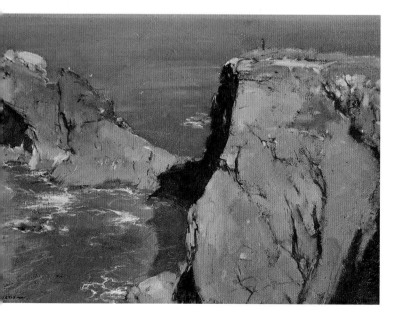

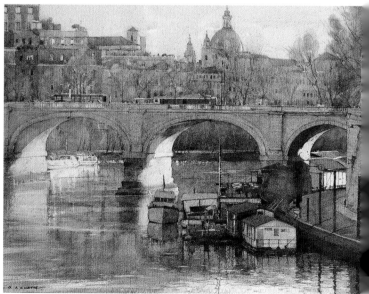

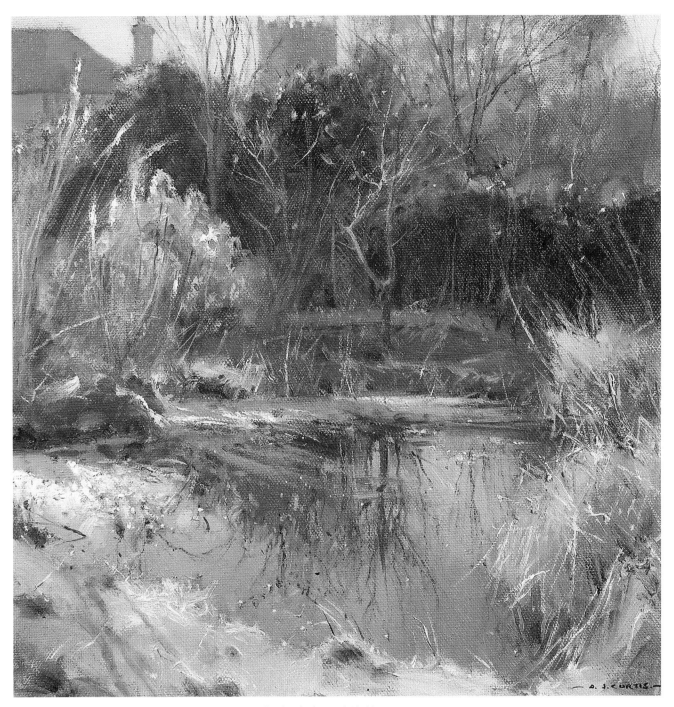

Above *Midwinter Reflections in the Pond, Gibdyke House*
Oil on board
30.5 x 30.5cm (12 x 12in)

I painted this in our garden, inspired by the wonderful
effects of the light on the pond.

Critique

River Fowey at Doublebois

This beautifully lit, peaceful subject had so much potential that I decided to work on quite a large canvas, rather than on one of the small prepared boards that I would normally choose. The weather seemed settled, and I judged that I would be able to continue the following morning at the same time. In fact, I spent three consecutive mornings on the painting. In a secluded valley setting, far from human contact, the subject had a very special sense of place.

The light was flat to start with, but I thought it might improve, and fortunately it wasn't long before the sun came out and created jewel-like shafts of light here and there on the trees, riverbank and within the translucent water. It was a simple composition, but a very effective one, with the addition of the figure as the focal point. After the blocking-in stage I worked on the tree shapes, which I wanted to express with the same energy that I had managed to initiate in the first part of the painting. For example, to keep the branches in the top left of the painting vigorous-looking, I left them as just single brushmarks.

I let the background be itself, with freely handled brushwork, concentrating most of my effort on the surface and the translucency of the water. The flashes of golden light on the dead leaves in the water contrasted with the pinkish light on the bank and the white Cornish light in the middle distance. It was a challenging subject for a large *plein-air* painting, but a very rewarding experience.

Right *River Fowey at Doublebois*
Oil on canvas
40.5 x 51cm (16 x 20in)

5. Speed and confidence

When painting outside, there is a great advantage in being able to work quickly and confidently. Essentially, success with *plein-air* painting relies on being able to seize the moment, focus on the key elements of a subject and, working with appropriate techniques, capture the mood of the scene with speed and economy. This means developing skills as a quick thinker and organizer, as well as being adept at colour-mixing and paint-handling. On the practical side, there are factors that can help you to work more quickly: ensure that your materials suit you as an individual, work with a limited colour palette, and do not be over-ambitious with regard to subject matter and scale.

Of course, it takes time and experience to develop a confident *plein-air* working process. Inevitably there can be quite a lot of disappointments to begin with, but it is a matter of perseverance, gradually acquiring the discipline, mindset and practical skills that will help you succeed. Every *plein-air* experience will teach you something, whether the resultant painting is a great success or a failure. The more you go out and work on the spot, the more confident you will become. Keep your work – the good and the bad – and review it periodically. Note where you have made progress and where you need to improve.

Opposite *Pembrokeshire Village Coastline*
Oil on board
30.5 x 25.5cm (12 x 10in)
As you gain confidence, you won't mind so much painting in places where your work can be seen by passers-by. To capture this delightful view, I had to work from the narrow coastal path, where inevitably people were squeezing past me now and again.

Scale and format

The scale and format of a painting – how large to make it and whether it should be a landscape, portrait or square shape – are aspects that are principally determined by the subject's content, although other factors, such as the prevailing light conditions and your degree of confidence, will play their part. Generally speaking, choose a small scale for a simple subject and a bigger scale for something more complex. If you try to convey a simple subject on a large scale, it is more than likely that there will be some big areas of nothingness and it will prove very difficult to make those interesting. Equally, if you try to cram a stunning, complex composition on to a small 20.5 × 25.5cm (8 × 10in) board, you are just not going to have enough space to make the information coherent and 'readable'.

I chose a square format for *Hollyhocks and Deckchair, Gibdyke House* (below), because it would perfectly suit the composition I wanted, encompassing the three main elements of the deckchair, the hollyhocks and the tree – so creating a diagonal flow from the bottom left to the top right of the painting. And because this was just outside my studio, in our garden, I was able to work on a larger scale than usual.

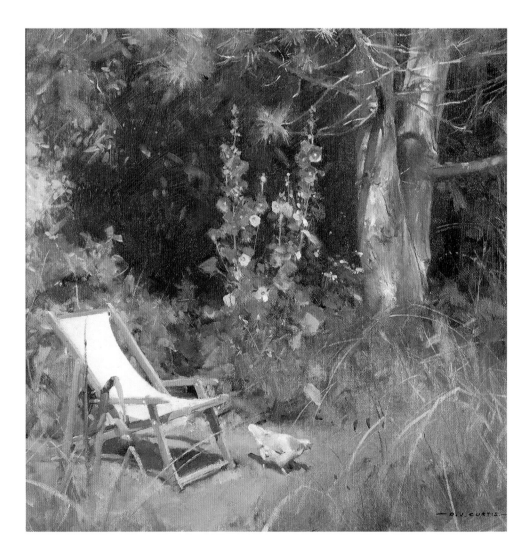

Right *Hollyhocks and Deckchair, Gibdyke House*
Oil on canvas board
51 x 51cm (20 x 20in)
With its three main elements arranged in a diagonal flow from bottom left to top right, this composition perfectly suited a square format.

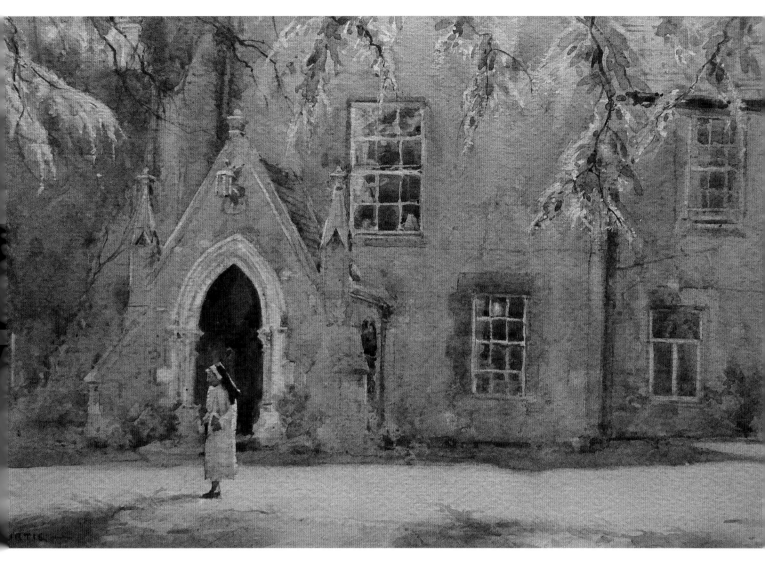

Size, shape and subject matter

A useful, versatile size for *plein-air* oil painting is 25.5 × 30.5cm (10 × 12in), which
is neither too big nor too small. Not quite square, it is an adaptable shape that can be
used effectively either way round – in a vertical or horizontal format – to suit different
compositional ideas and types of subject matter. This format is a particularly good choice
to take on painting trips abroad. I often take a dozen or so boards of this size, packed
together in a purpose-built carrying case. For watercolours, I mostly work on a 31 × 41cm
(12 × 16in) Arches 300gsm (140lb) Aquarelle block (Rough surface). The advantage of this
type of paper is that it does not need stretching.

 For oils, another lovely size and shape is 40.5 × 51cm (16 × 20in), which again can be
used in either a vertical or horizontal format, as can the larger 45.5 × 61cm (18 × 24in)
shape. And quite often these days I like to use a square format, perhaps 25.5 × 25.5cm (10
× 10in), 30.5 × 30.5cm (12 × 12in) or 40.5 × 40.5cm (16 × 16in). In fact, I usually take
out with me a variety of shapes and sizes, chosen from the stock of over 50 or so prepared
boards in my studio. As I have mentioned, it is best to keep to a reasonably small scale for

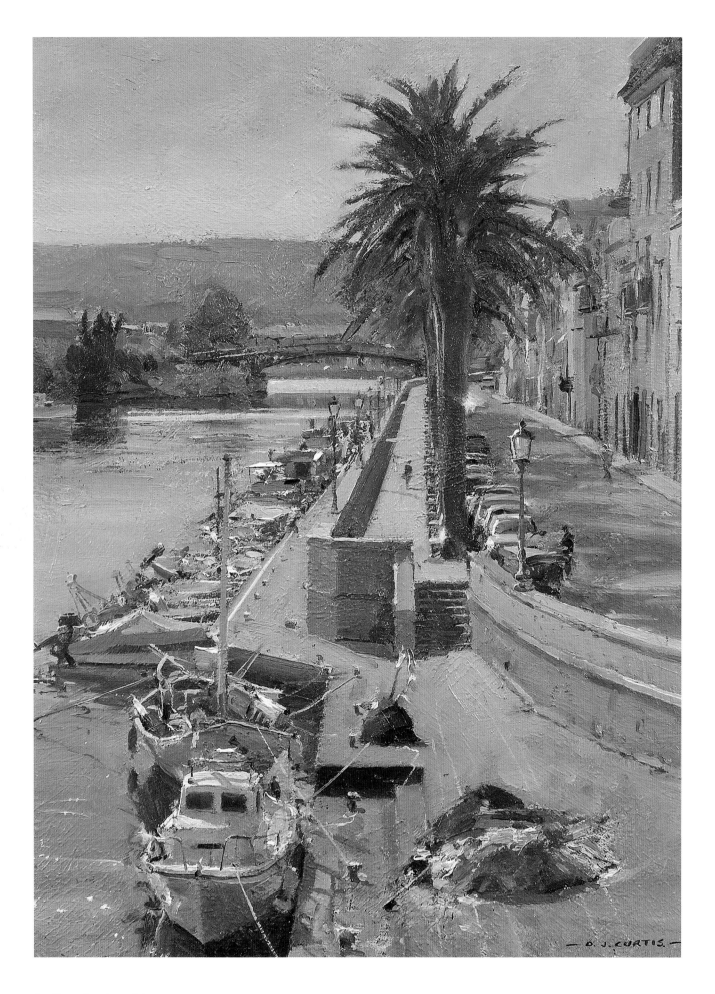

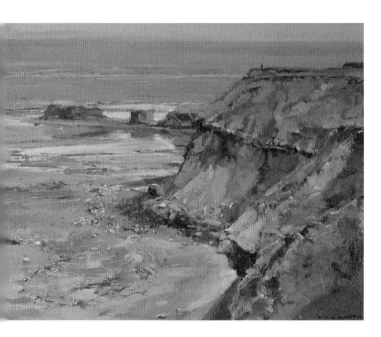

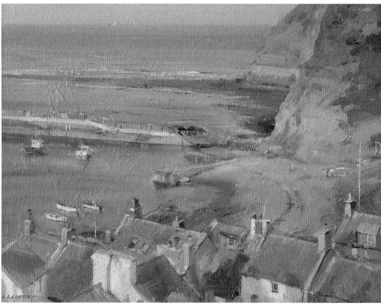

Above *Saltwick Nab, Whitby*
Oil on board
23 x 30.5cm (9 x 12in)
I painted both this painting and
*Advancing Shadows, Staithes
Harbour* (right) on the same day.
They have obvious similarities: I think
that you have a certain mindset on
some days when you are out, and
want to explore a particular theme.

Above right *Advancing Shadows,
Staithes Harbour*
Oil on board
23 x 30.5cm (9 x 12in)
This is an evening painting, following
on from my painting at Whitby
earlier in the day (above left). I
usually start a day's painting with
oils because I can work quickly and
more confidently with that medium.
Mostly I keep to one medium, but
sometimes I find that a change of
medium will give an added stimulus
for a piece of work.

working on site, choosing a format that suits the subject matter. You might need a vertical format – perhaps 35.5 × 25.5cm (14 × 10in) – for a townscape scene, for example, but a more horizontal format – say a 23 × 45.5cm (9 × 18in) – if your subject is a broad stretch of landscape.

For *In Contemplative Mood* (page 81), I cropped a sheet of half-imperial watercolour paper to create the more horizontal shape that I needed to suit this subject, in which I wanted to concentrate on the interesting configuration of the doorway and windows. The long, narrow stretch of foreground meant there was a danger that the eye would be carried out of the painting left and right, but I managed to counteract this by the considered placing of the figure and the foreground shadows. In contrast, the dynamic composition in *From the Bridge, Bosa Marina, Sardinia* (opposite), with its high horizon and wonderful sense of distance, would only work successfully with a vertical format.

Above *Foggy Sunday Morning, York Station*
Watercolour on Arches Rough paper
45.5 x 61cm (18 x 24in)
I couldn't resist the amazing atmospheric effect here, with the fog creeping in and the almost deserted station. It was the ideal subject for a large watercolour, made using sketches and other reference material that I had gathered on site.

Time

Because time is always limited, it can be tempting to make a quick choice regarding subject matter and in so doing inadvertently set yourself difficult problems to overcome. So, if possible, spend a little time getting to know a location and its potential before starting to paint there. Go walking, looking and sketching to help you get in tune with the location and find the most appealing subjects to work on. Also, such experience helps in developing an eye for good composition. Generally speaking, if the positive elements within a subject outweigh the less interesting ones, there should be enough content and scope to produce a convincing result.

In any event, sketches and photographs are always useful as supporting reference for a painting, and they can be particularly helpful when, for some reason, it proves impossible to complete the painting *in situ*. Another temptation is to prolong the work on site because there are parts that you are not very happy with or the painting is taking much longer than you thought it would. But it is important not to stay too long, because the light will

change and the effect that initially inspired you will be lost. Also, the longer you spend on something, the greater the danger that it will become overworked – the colours will get muddy and the paint will be applied too thickly.

Time and technique

The first half-hour is always crucial. In that time, the aim is to reach a point where all the white surface of the canvas or paper is covered and you have established the initial blocking-in or 'ghost' wash. If, after half an hour, when you stand back and assess the painting, you are happy with the composition, the colour and the tonal relationships, this should give you the confidence and motivation to continue. Alternatively, if you notice weaknesses, this is the time to make some corrections, before the work is too advanced. However, if you get into real problems with the painting and seem unable to resolve them, my advice is to abandon the painting and start afresh. It rarely pays to struggle with a lost cause for a long period.

Below *Boats Resting in the Harbour* Watercolour on Arches Rough paper 28.5 x 39cm (11¼ x 15¼in) Shapes such as boats need a lot of careful observation and accurate drawing. If you are unable to complete the necessary detail on site, take some photographs for reference and finish the painting later at home.

Above *Shadows on the Cliffs, Staithes*
Oil on board
23 x 30.5cm (9 x 12in)
This painting required a lot of colour-mixing and this is another aspect of *plein-air* work for which speed is an asset. But the more you practise, the quicker you become.

For *Boats Resting in the Harbour* (page 85), I took advantage of the fact that I would have slightly more time than usual, perhaps up to three hours, because the tide was out. I knew the shadows would gradually change, but the boats themselves would stay exactly as they were. With this painting I also had the advantage of working from the sea wall, above the subject, in a quiet, undisturbed position, on a still, warm day – so everything was favourable! Nevertheless, as usual, success depended on that first variegated wash. I needed to create gently diffused colours and textures, with lost-and-found edges, to give a convincing sense of the muddy foreshore, having carefully drawn and reserved the boat shapes. Then I could concentrate on the intricacies of the boats.

Similarly, with the oil painting, *Shadows on the Cliffs, Staithes* (above), which is another view from the same harbour wall, the conditions were quite settled, so there was more time to concentrate, analyse and resolve. More time means that you can take greater risks with the subject matter. Here again, the boats required careful observation and drawing, and in this case a lot of accurate colour-mixing. This is something else that comes with experience – the ability to mix appropriate colours quickly and instinctively. Sometimes now I find

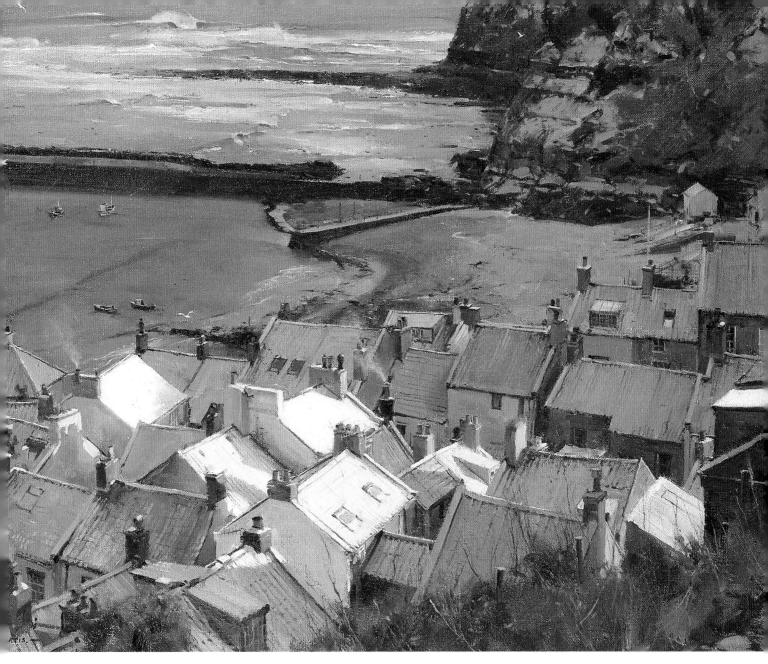

Above *New Year's Day Morning,
Above Staithes*
Oil on canvas
51 x 76cm (20 x 30in)
A very cold day, but a stunning
subject! I started with a small
pochade-box study made on
site to record the main shapes,
shadows and lit areas, and later
I developed the idea on a larger
scale back in the studio.

that I am mixing colours without even looking at the palette! This requires an intimate familiarity with the layout of the colours.

Winter work

Form and structure in the landscape are more obvious in winter and often there are amazing light effects to paint, especially on cold, clear, frosty days or during a high-pressure settled period after snow. It is possible to paint outside in the winter for short periods, providing you wrap up well and are realistic about how much can be achieved. Often the best plan is to make a start outside and then finish the work indoors, or make sketches and take photographs for reference. Sometimes, if the weather is settled, you can return to the same spot on two or three successive days and complete a painting that way.

Winter, Church Street, Misson (page 88) is an example of a painting produced during a quiet, settled period, when I was able to return the next day for a second session of an hour or so. I used the 'rub-out' technique for this painting, starting with a white board. I applied

a mid-tone wash all over the board and then, with a rag, wiped away the wash in those areas which would be the very lightest parts of the painting – essentially the snow-covered areas that were in full sunlight. The subject was ideal for a quick, winter plein-air approach. It wasn't too complicated and it had the sort of shapes that could be quickly blocked in. There was also the advantage that it wasn't far from my studio.

In contrast, for *Windswept Pines About Sleights* (opposite), I decided to rely on photographic reference. It is a subject that I know well and which I have painted many times before. However, this view was right beside the main road. So, given the cold conditions and the traffic, I thought that a studio painting, from photographs and my knowledge and impressions of the location, would be the best option.

Above *Winter, Church Street, Misson*
Oil on board
25.5 x 35.5cm (10 x 14in)
Often, on a still winter's day with low light, there will be some wonderful shadows and subtle variations of rich colour, as here.

Opposite *Windswept Pines Above Sleights*
Oil on linen canvas
66 x 51cm (26 x 20in)
I have painted at this location many times before, but because this particular view is right next to a main road and it was a very cold day, on this occasion I decided to work from reference material and my knowledge of the subject.

Above *Midday Light on the Foreshore, Staithes*
Oil on board
23 x 30.5cm (9 x 12in)
I loved the poetry of all the different shapes here; the best view to be had was from the very edge of the cliff!

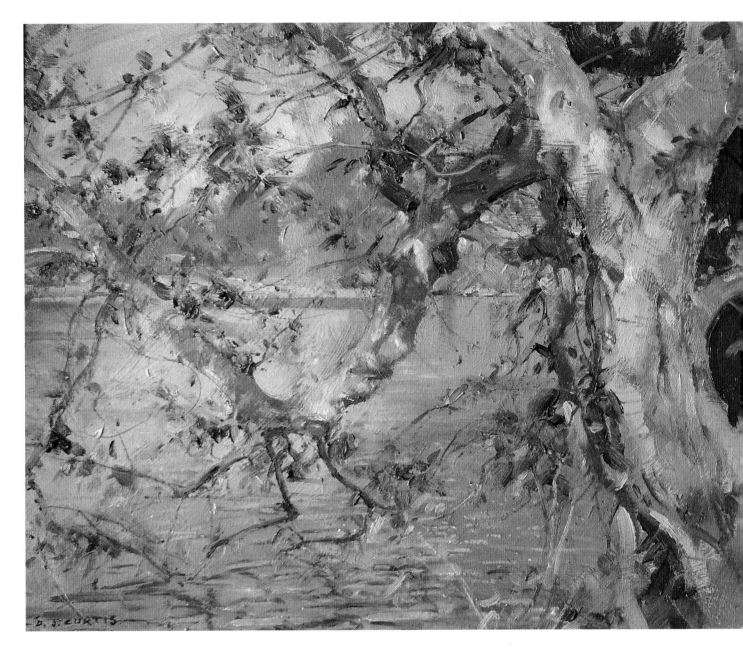

Varied challenges

Although in choosing a subject to paint you want to find something that is achievable and will allow you to work with speed and confidence, this need not preclude tackling a subject that will test your ability to some extent. Finding a subject that offers a degree of challenge will be far more beneficial to your general progress and development than always playing safe and only attempting subjects that you know are well within your capabilities. Paintings should always be challenging to some extent, I think, because it is by tackling those challenges and successfully overcoming them that we gradually become better painters. We gain experience and knowledge from the way we solve the different problems encountered during the painting process.

Above *Outstretched Branch Across the Lake, Sandbeck*
Oil on board
25.5 x 30.5cm (10 x 12in)
I relish a challenge, and this subject – with the outstretched branch of the tree, glinting light on the water and no obvious foreground – was certainly that.

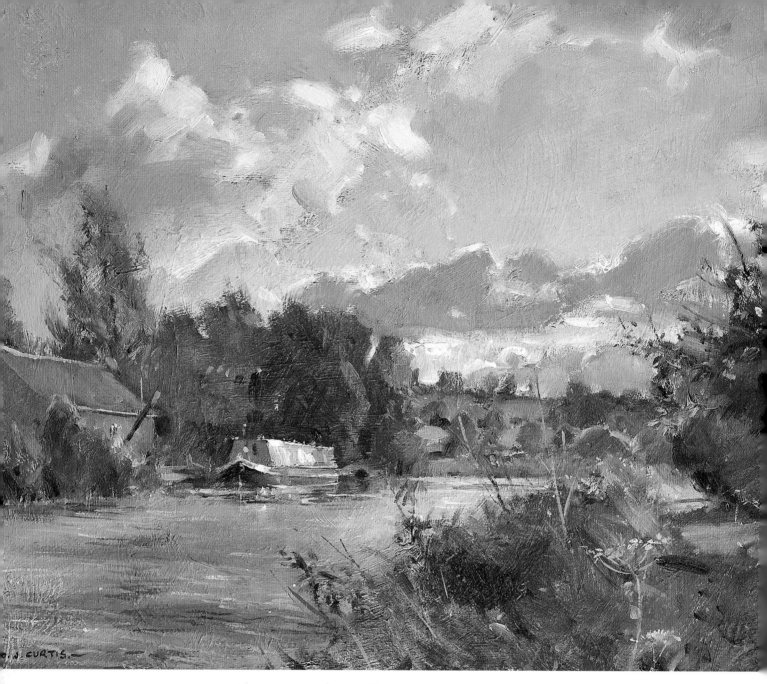

Above *Scudding Clouds Above the Chesterfield Canal*
Oil on board
25.5 x 30.5cm (10 x 12in)
The challenge here was the sky: I wanted it to add meaning and impact to the composition, and this meant having just the right placement of clouds so that they would help the flow of interest around the painting.

Process and practice

Sometimes the challenge is the location itself – in finding a safe spot from which to work. For *Midday Light on the Foreshore, Staithes* (page 90), for example, I was perched right on the edge of a cliff top. It was the only way to observe this particular view, which offered an amazing composition with the poetry of all the different shapes. But safety must always come first, of course. I am used to heights: I have been climbing for much of my adult life. In really exposed, dangerous situations such as this, I usually prudently choose to wear a climbing harness if a suitable anchor point is available.

It was late afternoon when I came across a wonderful tree leaning out over the water, which can be seen in *Outstretched Branch Across the Lake, Sandbeck* (page 91). It reminded me of a figure pose, with an outstretched arm, and it certainly proved just as challenging! But I thought it looked a quirky subject and I was ready to have a go. There were added challenges too in the fact that there was no foreground and because I wanted to achieve a

'Monet' effect with the surface of the water – using variously placed horizontal flashes of different colours, side by side, allowing the eye to carry out the mixing process.

In contrast, in *Old Farmstead near Clayworth* (below), the main challenge was how to make the foreground more interesting and make it work in relation to the rest of the painting. In the end, I decided to make the most of the two daggers of light reflecting from the worn-away chalky pathways, to keep the viewer's interest within the foreground area. And I also included a small amount of textural work in the foreground grasses. Sometimes you have to exaggerate and be a bit inventive in order to make a painting work visually and create the necessary impact.

Below *Old Farmstead near Clayworth*
Watercolour on Arches Rough paper
28.5 x 39cm (11¼ x 15¼in)
I love old farmyard scenes like this one, which I painted on-site on two consecutive summer days. Essentially, it is a painting all about drawing and some simple watercolour washes.

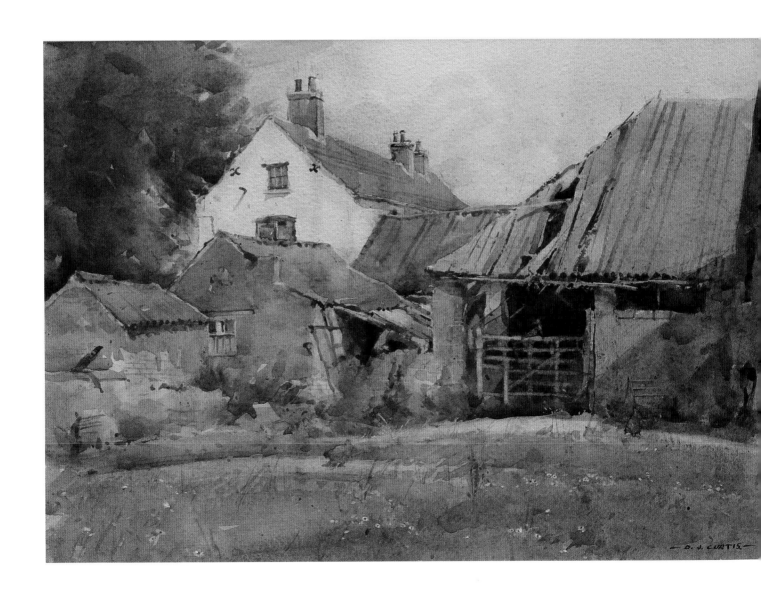

Critique

Gunnera by the Pond

If you have a garden, or are able to paint in a friend's garden, it is a good place to start with *plein-air* painting. You won't have to carry equipment very far, you won't be disturbed by inquisitive passers-by, and you will have the advantage of being able to return the following day if you need to. It is a good way to get an idea of what's involved with *plein-air* work and build up some confidence.

These magnificent gunnera plants are in our garden, just a short distance from the studio. In effect they make a kind of grand outdoor still-life subject (and are the nearest I get to painting a still life). There are all sorts of compositional possibilities with these plants, but on this occasion I decided on a vertical format which would contain the glorious light effect, with the pond just creeping in at the bottom left. It was a subject that suited oils, I thought, and I chose to work on a dry board that had been prepared with a blue-green ground made from a mix of French ultramarine and raw sienna.

This immediately established the right sort of mid-tone to work against. I blocked in everything, working with fairly impasto strokes and defining the leaf shapes by cutting in around them with the dark shadow tones. For the sunlit leaves I used a mix of Indian yellow, Naples yellow and a touch of viridian. I kept the background quite simple, so that it did not compete with the dramatic effect of the light coming through the leaves, and echoed the light, triangular shape of the roof above with a similar shape in the foreground.

Opposite *Gunnera by the Pond*
Oil on board
40.5 x 30.5cm (16 x 12in)

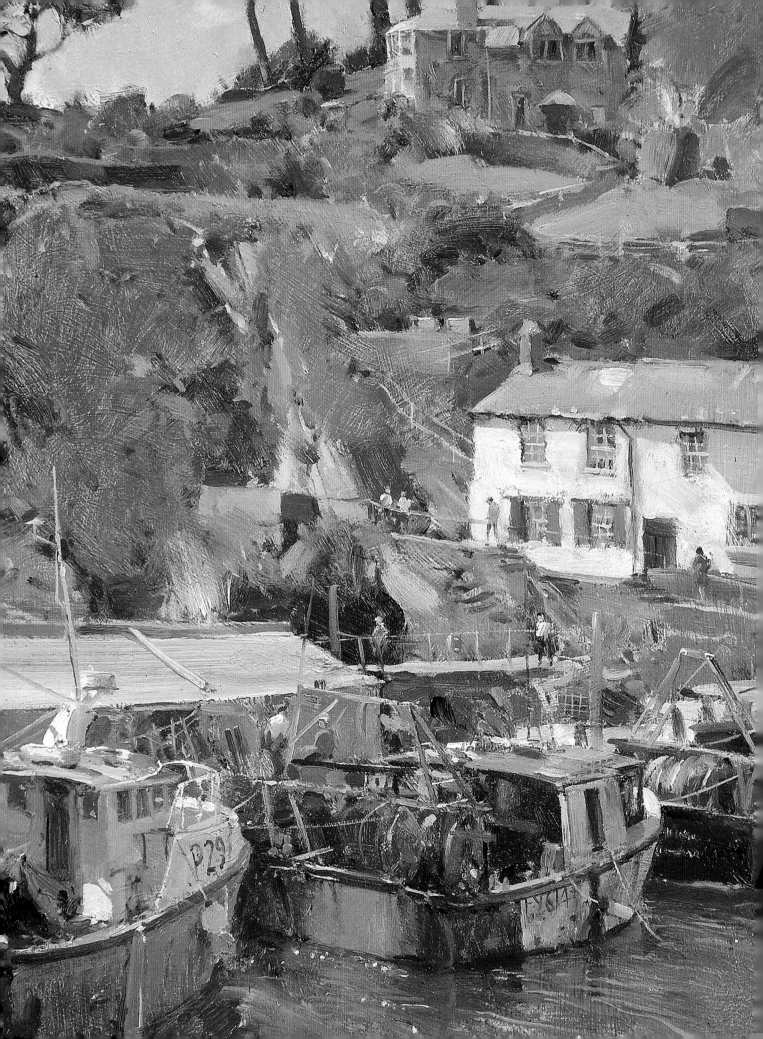

6. Subjects and locations

Wherever you are, there will usually be something interesting to paint. You might find a subject that immediately appeals, or perhaps there is something that is almost right but needs a little imagination to tease out the best composition and impact. If you have never painted outside before or lack confidence in your ability, start with something simple – for example, a study of a single boat, part of a street scene with just a few buildings, or a simple landscape based on an individual, characterful tree as the centre of interest. Look for a subject with simple block shapes that will help create a satisfying and achievable result. As I have mentioned, working in your garden or from a window or doorway can be a good way to start, as it gives a high degree of privacy.

Opposite *High Water, Midday, Polperro Harbour*
Oil on board
35.5 x 25.5cm (14 x 10in)
Obviously, with any *plein-air* painting you have to be realistic about what can be achieved in the time available. In fact, I was a bit greedy here by incorporating the trees at the top, but I knew that this would make a better composition. Nevertheless, I was very selective from the immense variety of possible subjects available in Polperro harbour.

Variety

I find many of my subjects at coastal locations, where land meets sea. For me, coastal scenes are much more likely to have the key qualities that I look for in a subject, namely appeal, composition and tone. The coast offers plenty of variety, with beach scenes, interesting old boatyards, harbours, and rugged cliffs and coastal landscapes. Moreover, these subjects remain interesting throughout the year and, of course, the light is different and often more dramatic and exciting around the coast.

Variety is a good thing. The challenge of new subjects can help keep your work exciting and forward-looking. So, although the coast is my principal source of inspiration and I am still able to find interesting views at Staithes and other favourite locations, I also like to paint landscapes, street scenes, farmyards, interiors and other subjects. Unfortunately, due to modern methods of farming and infill building in many villages, it is becoming increasingly difficult to find the unspoilt landscape views, villages or old barns and farmyards that used to be so prevalent. But there are still a few about, and they are always a real delight when I discover them.

Whenever you go out, even when you have no fixed plans to do some painting, it is always worth having some sketching or painting materials with you – just in case! You never know when you might come across a fantastic subject to paint, and it is very frustrating if you have no means of recording it. I usually have a small pochade box (containing basic oil-painting equipment) with me. This proved fortuitous, for example, when I was on holiday with my family on the Isle of Wight and came across the wonderful old woodyard

Below *Old Wood Mill, Isle of Wight*
Oil on board
20.5 x 30.5cm (8 x 12in)
Be prepared for the unexpected!
I came across this wonderful subject
quite by chance, and fortunately
I had my oil-painting pochade box
with me.

Above *Old Willow on the Bank of the Idle*
Oil on board
20.5 x 30.5cm (8 x 12in)
What a difference interesting light can make to a subject. This is just a tree, but with the added effect of the sunlight, it makes a very powerful image.

and millhouse shown in *Old Wood Mill, Isle of Wight* (opposite). Surprisingly, this was in the middle of a theme park. I painted it on a small 20.5 × 30.5cm (8 × 12in) board, sitting among all the holidaymakers!

Old Willow on the Bank of the Idle (above) was also painted on a small, prepared board, 20.5 × 30.5cm (8 × 12in), again entirely on the spot. This was a simple, local subject, full of impact in the way that it was so beautifully lit. In contrast, for *Diffused Afternoon Sunlight, Staithes* (page 100), during a period of settled weather I was able to work on a large scale, with painting sessions on two consecutive days. I did the drawing and 'ghost' washes on the first day and added the necessary further superimposed washes and definition on the second day. There is immense potential for variety in subject matter, media and approaches, as these three paintings demonstrate.

Above *Diffused Afternoon Sunlight, Staithes*
Watercolour on Arches Rough paper
39 x 57cm (15¼ x 22½in)
If weather and time are on your side, you can attempt something more ambitious and work on two consecutive days, as I did here.

Themes and variations

The most informed and visually exciting paintings are often those that result when you have gained a strong relationship with a particular location and developed a real knowledge and understanding of it over a period of time. Some artists like to concentrate on a theme of this kind, finding their inspiration from just one source, such as a certain tract of landscape or an individual town or city.

For me, the attractive coastal town of Staithes, in Yorkshire, has been a constant source of ideas throughout my career. Because I now have a total familiarity with the harbour and town, I can find views and subjects that other people might easily miss. I know how the various effects of tide and light will influence different views and scenes within the town and how I can take advantage of those effects to find dramatic subjects to paint.

Obviously, in concentrating on a theme of this type, there is always a risk of what I call 'location burn-out'. Every new painting should present a fresh challenge, so it is important to find something different to express. Repeating ideas will simply lead to dull and tired-

Above *Drying Nets, Whitby Harbour*
Oil on canvas
45.5 x 56cm (18 x 22cm)
If you add figures later, back in the studio, make sure they are well drawn, thoughtfully placed and fit in with the rest of the painting.

looking results. In fact, I am still finding something new to say about Staithes, and in any case, as I have explained, I also paint a wide variety of other subjects.

In Staithes I can find interesting, intimate subjects rich in the drama of light and composition, and I paint these rather than the well-known tourist sites. This is the advantage of getting to know a location well: on a fleeting visit, you are only likely to notice the obvious subject.

Similarly, when I go to Venice, I look for strong elements of light and composition – scenes that capture the atmosphere of Venice, though avoiding the obvious sights. Always capitalize on your individual style: don't be afraid to put your own interpretation on what you see and express it in a personal way. As you get to know a particular location, you will discover that there can be a great deal of variety within a single theme.

Above *Sparkling Light, West Stockwith Basin*
Oil on board
30.5 x 40.5cm (12 x 16in)
With *plein-air* work it is always a good idea to place the extreme lights as soon as you can, in case the light should change. Then you can assess and add the darker tones relative to those initial light areas.

Opposite *Canal Study, Venice*
Watercolour on Arches Rough paper
28.5 x 38.5cm (11¼ x 15¼in)
Sometimes, ideas that start on site can lead to more resolved results in the studio later, as here. I started with a *plein-air* oil study and then used it as the reference for this studio watercolour painting.

─ D. J. CURTIS. ─

Above *Shadow Under the Bridge, Venice*
Watercolour on Arches Rough paper
39 x 57cm (15¼ x 22½in)
Here, I made the drawing on site but
did all the painting in the studio.

Assessing subjects

Whatever you choose as a subject, it is important that it excites you and that you have a strong desire to paint it. This initial reaction to a subject is always a key factor in creating a successful painting. Without that inspiration, the painting is likely to be more of a struggle and consequently the result will lack feeling and impact. But however excited you are, don't be tempted to rush into starting the painting before you have spent a few minutes assessing the subject and deciding on the approach you want to take and the aspect you want to concentrate on. Check that you have found the best viewpoint, that the composition works well, and that you know what sort of colour palette will enhance the mood and effects you want to achieve.

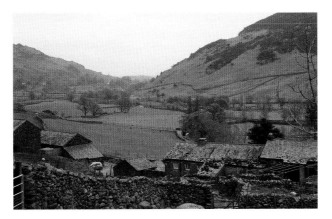

Right *View Across the Langdale Valley*
Location photograph.

Right Stage 1
For *View Across the Langdale Valley* (page 108) I began by making a quick drawing, adding the foundation 'ghost' wash and establishing the correct tonal value for the distant hillside.

Staying focused

Painting trips do not always go according to plan and so sometimes you have to be prepared to adjust your expectations and perhaps also adopt an approach of perseverance. This was certainly the case when I made a return visit to the Langdale Valley in the Lake District in the spring of 2012. The weather was atrocious. It was cold, wet and windy, but I had planned to do some *plein-air* watercolour painting for the film version of this book (*Painting on Location*, APV Films) and so, with a film crew there, I was committed. It was painting at the extreme, and it demanded all my reserves of experience, physical and mental energy, and staying power – creativity beyond the norm!

During a short window of opportunity, before the rain set in, I painted *View Across the Langdale Valley* (page 108). I chose that subject because I had painted there before and so

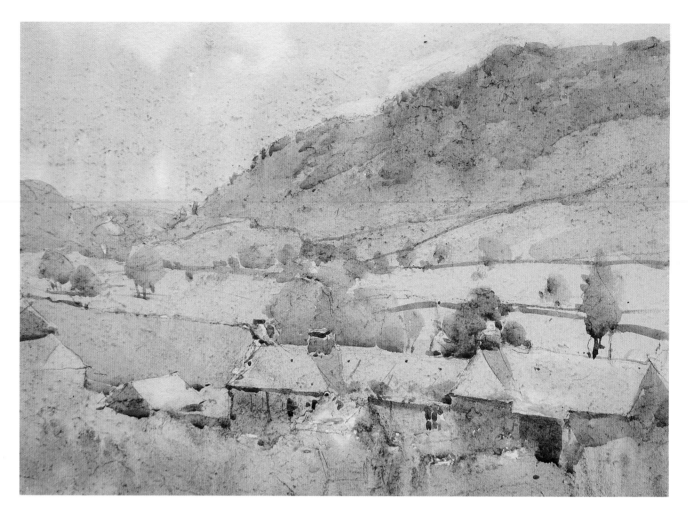

Above *Stage 2*
Next, I worked on the content of the background area and added some structure to the foreground buildings.

I knew where to place everything and that the composition would work successfully. Initially the light was quite good and I wanted to capture that effect as quickly as I could in the 'ghost' wash. I could see that the light would soon become more diffused and eventually go completely flat. I made a quick, simple drawing, adding the variegated ghost wash – blue, green and steel-blue washes, all fusing together to establish the underlying colour and tonal values, with no hard edges – working on a slightly toned, biscuit-coloured Two Rivers paper (Stage 1, page 105). Then I looked again at the far distant hillside area. I needed to get this tonally correct, which in turn would help me judge the tonal values for the rest of the painting.

Because of the damp conditions, drying the painting was a big problem. In fact, I was able to borrow a gas torch which, held about 15cm (6in) above the paper for a short period, greatly speeded up the drying process. Next, I worked on the background area, adding the three different trees and then some structure to the foreground buildings (Stage 2, above). Now, despite the awful conditions and after the first (set-up) stage, which is always a bit worrying, I was gaining confidence. I was more optimistic about achieving a successful result despite the adverse conditions.

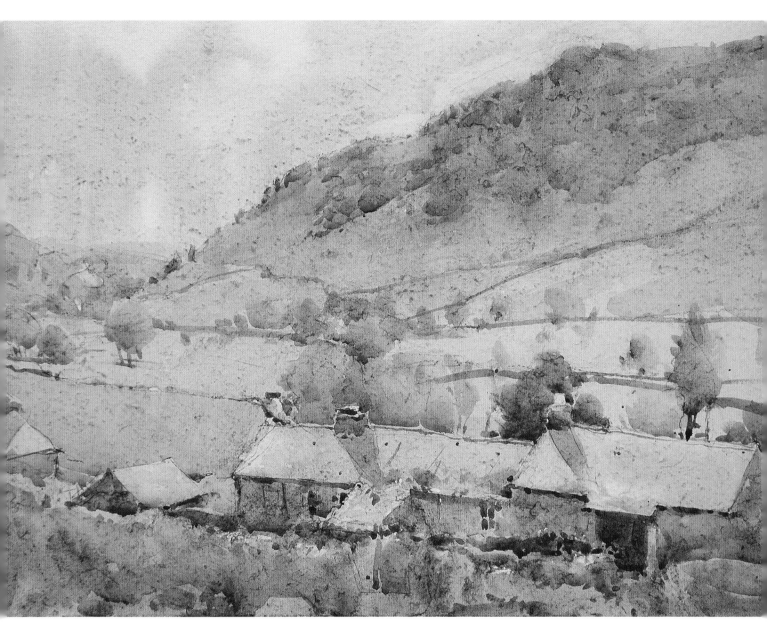

Above *Stage 3*
Working quickly in the cold, damp conditions,
I finished the detail and definition of the
foreground area.

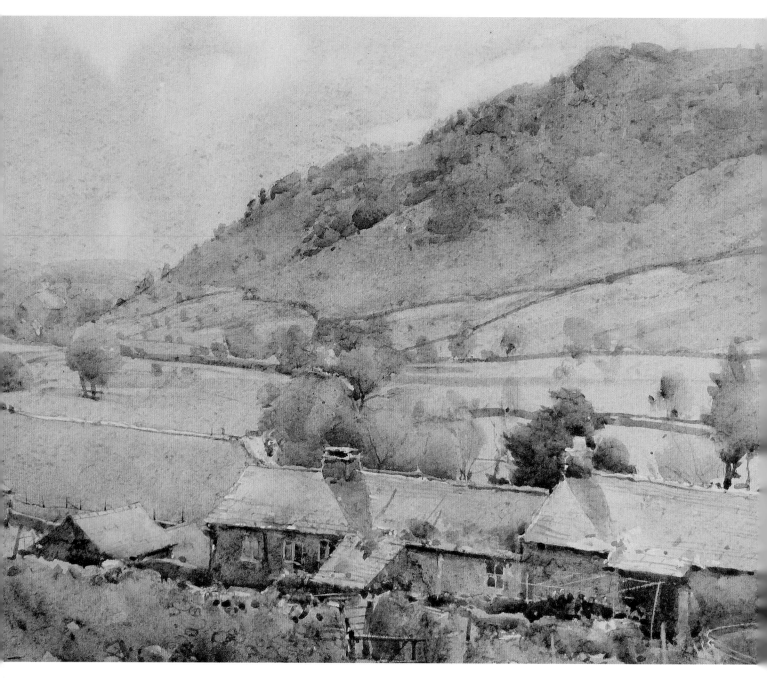

Above *View Across the Langdale Valley*
Watercolour on Two Rivers tinted paper
28.5 x 38.5cm (11¼ x 15¼in)
This shows some final tidying up. I looked at the painting again when I returned to the studio but decided to leave it exactly as it was – an honest *plein-air* work.

I dried the paper again with the gas torch and then concentrated on the foreground buildings and stone walls (Stage 3, page 107), before adding the final details and making some of the edges crisper (*View Across the Langdale Valley*, above). It was a truly challenging painting, but a very rewarding one.

A sense of place

Capturing a sense of place depends not only on expressing the distinctive features and characteristics of a subject, but also on conveying its particular mood. For example, in a Staithes subject there will be architectural elements in the form of stone cottages, pantile roofs and cobbled streets, and obviously these features help to capture the atmosphere of the village. But equally that atmosphere is influenced by light, weather and other factors, and these must somehow be interpreted and allowed to play their part in the painting.

For me, mood is usually synonymous with light, so I automatically look at the tonal values and how these, in turn, influence the colour key and overall impact and drama of the subject. Other factors, of course, are your own personal style and reaction to the subject – what you feel is important about it and worth emphasizing. And, as you can see in the paintings throughout this book, the choice of medium and technique always has a profound influence on conveying a particular mood and sense of place.

Vital qualities

An essential skill in helping to express a sense of place, and in fact in creating a painting that has plenty of interest and impact, is the ability to recognize and clearly state the vital qualities of a subject. In *Cala San Vicente, Mallorca* (page 109), for example, I felt that the sense of place was determined by the contrast between the tranquility and cosiness of the beach in the foreground and the drama of the monumental cliffs in the distance. I decided that oil paint would be the best medium, as it would allow me to use a wide range of different textural handling effects – for the sky, the cliffs, the trees and so on. Note, too, how figures can add to a sense of place, but they must be carefully positioned and look totally in keeping with the rest of the painting.

Similarly, for *Fine Spring Morning, Chesterfield Canal* (left), to interpret the feel and mood of the subject, much depended on the choice of medium and the way that the paint was applied. Look at the scurrying clouds in the sky, for example, the feathered edge of the foliage of the willow trees, the crystal-clear reflections in the river and the loosely described foreground grasses – these all help to build the sense of a lovely bright day in a quiet rural setting.

Obviously it is easier to be in tune with qualities such as mood, atmosphere and sense of place when you are actually painting on site, although of course it is equally important to capture those qualities in the studio when working from reference material. So, when you are developing an idea in the studio, try to instil into it some of the same excitement, energy and spontaneity that you would have when painting *en plein air*. You may want a more resolved result in the studio, but it must still evoke a moment, a mood and a sense of place.

Left *Fine Spring Morning, Chesterfield Canal*
Oil on board
20.5 x 30.5cm (8 x 12in)
I wanted to accentuate the majesty of the trees here and decided that the composition would work best from a very low viewpoint, so I sat on the ground to paint this subject.

Above *Beachscape, Monterosso al Mare, Cinque Terre*
Watercolour on Arches Rough paper
39 x 57cm (15¼ x 22½in)
On site I had time to make a small oil study of this scene, but I always had in mind the larger watercolour version shown here, because it was such a wonderfully atmospheric subject.

I painted *Beachscape, Monterosso al Mare, Cinque Terre* (opposite) in the studio, from an oil study made on site. I thought the subject would work well at a larger scale in watercolour, using the lost-and-found technique. The subject had a wonderful atmospheric quality that would perfectly suit watercolour. Similarly, for *Windbreaks, Fistral Beach, Newquay* (above) my reference was a small *plein-air* oil study in which essentially I had captured the effect of the light and the basic composition, knowing that I wanted to produce a larger version in the studio later. The large painting enabled me to incorporate groups of figures and create a much more impressive result.

Above *Windbreaks, Fistral Beach, Newquay*
Oil on linen canvas
51 x 76cm (20 x 30in)
Once again, back in the studio I was able to produce a more resolved and exciting painting based on the original *plein-air* study.

Critique

Late Evening Light on the Cliffs, Staithes

As I have said, when you really get to know a location, you develop a keen understanding of when the conditions are best for painting different views and features of the area, and this is how I came to paint this subject. I knew that the evening sunlight across the cottage roofs, particularly across the roof in the foreground, is always magical and creates some marvellous abstract shapes. I had often seen that wonderful shadow on the large pantile roof and the way that it leads the eye back towards the distant cliffs to begin a flowing rhythm around the group of shapes, and thought that the subject would make a simple yet very effective painting.

I painted it at 7.30 pm on a warm August evening. Especially in summer, early and late light is generally the best: there is more interest from the play of light and shadows and also from the colour relationships. Here, I particularly liked the transition from the golden ochre of the pantile roofs to the steely plum-grey/purple of the shadows. And there were some stunning dark blue shadows in the fissures of the cliffs contrasting with the various warmer blues of the sea.

The composition was just terrific. I could see that, by making full use of the way that the light/dark values broke up the foreground area, I could create some interesting patterns and work this to my advantage, with hard-edged/soft-edged harmonies. I also liked the V-shape created by the harbour wall and how this could be used to strengthen the design. Additionally, there were different textural qualities to exploit – using drawn horizontal strokes for the calm sea, for example, but more blocky brushwork for the buildings. The subject had good shapes and wonderful light, and that is always the foundation for possible success.

Opposite *Late Evening on the Cliffs, Staithes*
Oil on board
30.5 x 25.5cm (12 x 10in)

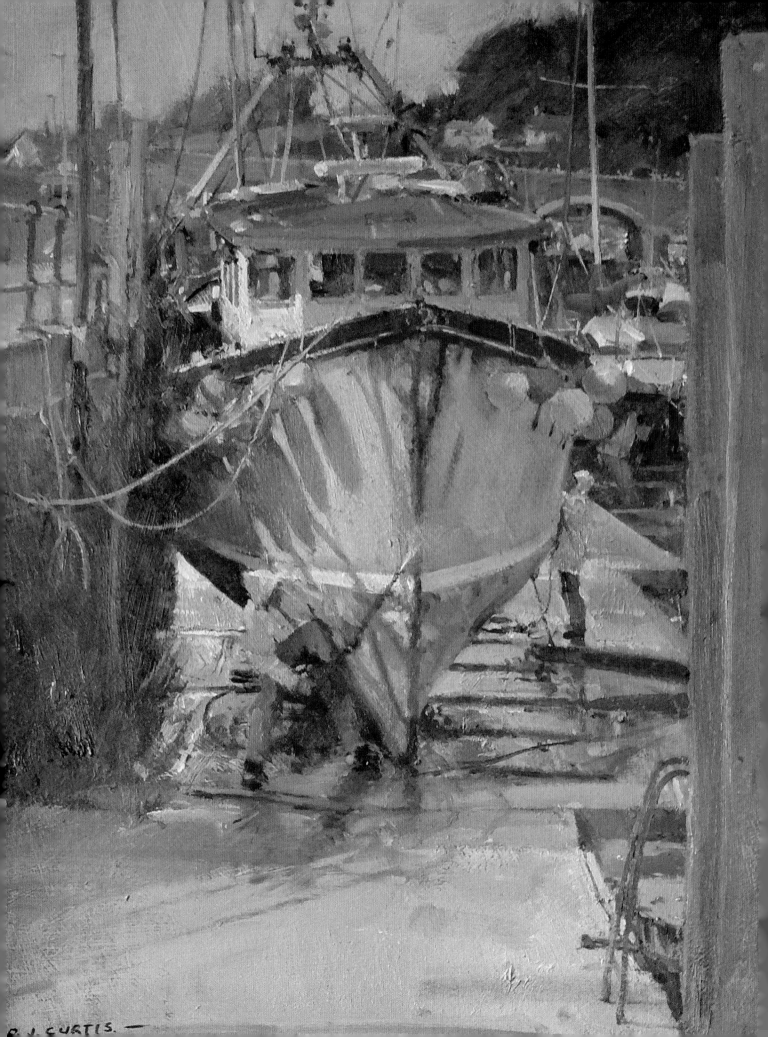

P. J. CURTIS.

7. Taking it further

With the pressure of time and other factors that come into play when working on location, it is not always possible to make the most of a stunning subject or finish a painting to the best of one's ability. Consequently, when you get back to the studio you will probably find, as I do, that while some paintings are best left alone, there will be others that need a little extra work to achieve maximum impact. It is quite justifiable to add a few finishing touches or rectify passages which, in the heat of the moment, have not gone well, providing such additional work is not overstated.

The best *plein-air* paintings have an attractive 'rawness': the brushmarks are meaningful and expressive. The aim in the studio should be to maintain that sort of quality and the way that it evokes a sense of place. You have to strike a balance between adjusting and firming up the marks made on site but not going too far and causing a painting to lose its feeling of spontaneity and contact with the location. Additionally, of course, in the studio you can develop ideas from sketches and other reference material gathered on site; complete paintings started on site but which, because of factors such as time and weather, or due to their complexity or scale, could not be finished outside; or produce a new studio painting from an existing *plein-air* painting, perhaps in a different medium or with added features or a different composition.

Opposite *Jet-Washing, Looe Harbour*
Oil on board
30.5 x 25.5cm (12 x 10in)
Figures always add interest to a painting, but it is important that they look convincing. You may need to do some further work on the figures back in the studio, using sketches and photographic reference.

Evaluation

Once you are back in the studio, evaluate your painting and decide what, if anything, needs to be done to improve it. Cast a critical eye over the painting or ask someone else whose opinion you value to have a look at it. Check to see if there is anything fundamentally wrong – perhaps the scale of a figure or a building, for example. Are there any highlights that need emphasizing, passages that need toning down or edges that need more definition? Concentrate on small adjustments that will help make the painting more convincing.

It is surprising how, in just half an hour and with a few brushstrokes, you can transform a painting from something that is almost successful into something with real impact.

It is often difficult to achieve the right scale and positioning of figures when painting on location and consequently some reworking may be required later in the studio. This was the case with *Jet-Washing, Looe Harbour* (page 116). On site I managed to place the two figures

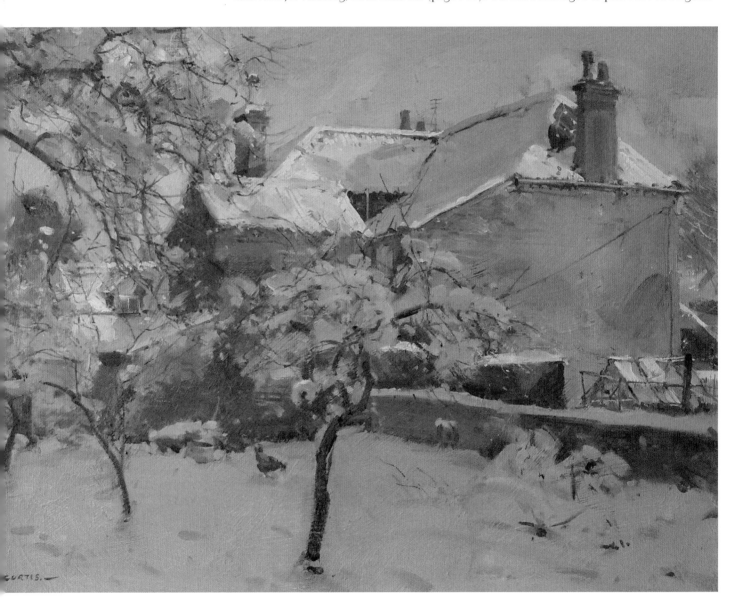

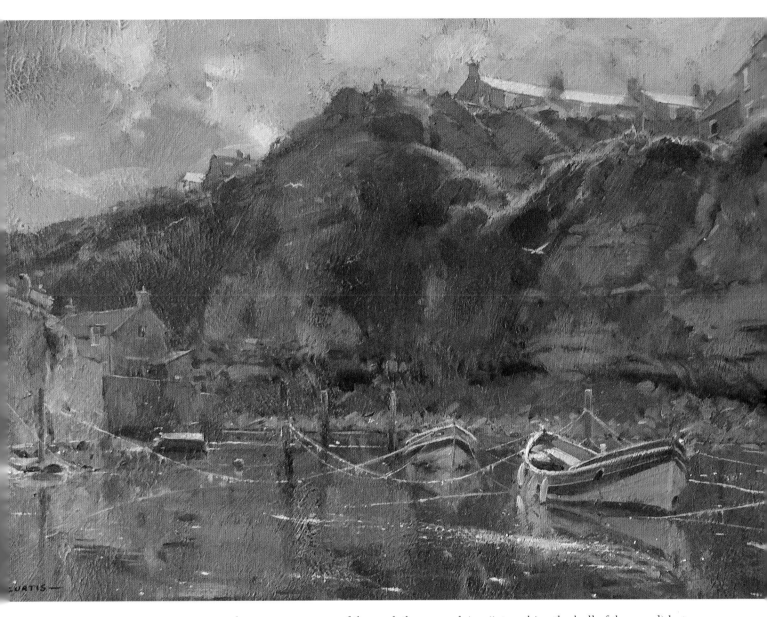

and create some sense of the work they were doing (jet-washing the hull of the vessel) but, because they were moving around all the time, I could not capture them as successfully as I would have liked. So, back in the studio, I repainted the figures, now working from memory and some reference photographs that I took on site. I was able to position the two men slightly differently, to add to the impact of the composition, and also make them more active and convincing. I made sure the figures were painted in keeping with the rest of the painting, which was left exactly as I had finished it on site.

Finishing touches

Mr Owen's Orchard, Misson (opposite), *Little Blue Boats in the Beck* (above) and *A Line of Fishing Vessels in the Outer Harbour* (page 120) are all paintings that were virtually completed on site but then had some finishing touches added in the studio.

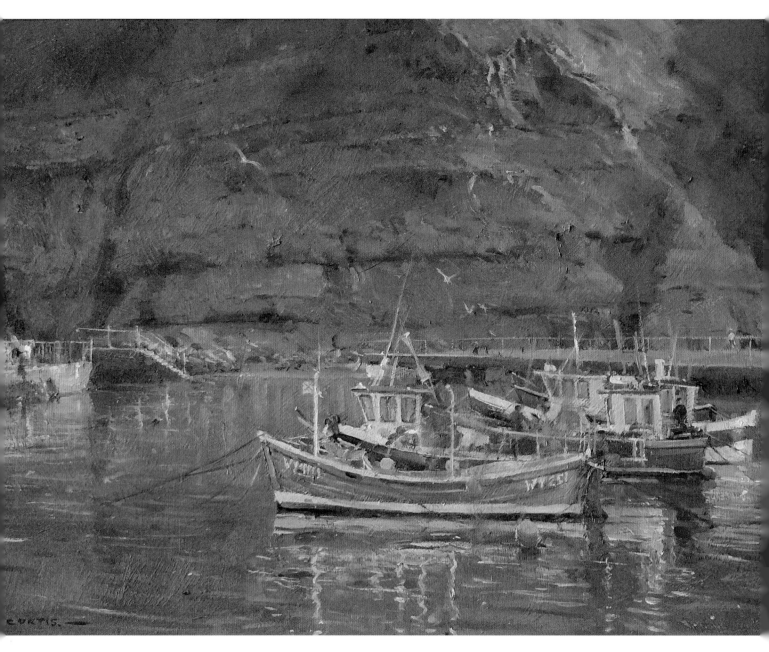

Above *A Line of Fishing Vessels in the Outer Harbour*
Oil on board
23 x 30.5cm (9 x 12in)
Like figures, boats must be well drawn, and some further work in the studio is usually necessary.

Mr Owen's Orchard, Misson is a painting of a subject that I know well – in fact it is my neighbour's house. I have painted in this orchard many times and consequently I know when the light will be at its best to give the most effective contrasts and so add to the impact of the composition. I painted this version in the middle of winter, with two sessions outside, on two consecutive days, and then a further short period in the studio. Outside, I was able to block in all the main shapes and create the sense of light and mood, with the lit areas and blue shadows on the roofs contrasting with the foreground area in deep shadow. In the studio I added the tracery of the branches, a little more detail in places, and one or two of our chickens for foreground interest.

For *Little Blue Boats in the Beck*, the studio time was slightly longer than usual, perhaps an hour. The reason for this was that when I looked at the painting, back in the studio, I noticed that I had inadvertently made the cottages on the left too small – they were out of scale with the rest of the painting. I guessed that I had been so entranced by the majesty of the cliffs and trying to capture that feeling that I had failed to judge the true scale of the cottages. There is a lesson to be learned from this, I think – every part of a painting must be given equal consideration if the overall result is to be a success. So here, the majority of the studio time was spent on repainting the cottages, although I also had to do some further work on the boats. It is always important to depict the shape and character of boats correctly, and I may take some photographs so that I can check these points when I return to the studio. Similarly, the main additional work for *A Line of Fishing Vessels in the Outer Harbour* concerned the placing, shape and detail of the boats.

The middle way

While it is always satisfying to finish a painting on site and so produce a 'true' *plein-air* work, equally it can be very rewarding occasionally to try something more ambitious and which relies on a combination of *plein-air* and studio approaches. Sometimes you will come across subjects that are worthy of a large scale and a more resolved style of work, and a good way to tackle these is to adopt what I call the 'middle way' – starting the painting on site but finishing it in the studio. The most important thing to remember, when working in this way, is to ensure that you complete enough on-site painting, and collect sufficient supporting reference information, to enable you to continue confidently in the studio.

I use this approach for both oils and watercolours. On site, my aim is to reach the stage at which I have blocked in all the painting and have a clear idea of how I want to develop

it. I often start by making a pencil drawing for reference, in which I will concentrate on composition and tonal values, and I might also take some reference photographs. For the watercolours, I work on either stretched Arches 640gsm (300lb) watercolour paper or sometimes paper from a Saunders Waterford watercolour block, beginning with a careful drawing. Then I apply masking fluid to the various light areas that I want to preserve and, having premixed quantities of the appropriate colour-washes, apply the overall variegated 'ghost' wash. If there is time, I do some further work to develop the balance of lights and darks and to enhance the sense of structure and form, but any remaining work can be done in the studio – working from my memory and impressions of the scene together with the reference material.

I follow a similar process for oil paintings. I start by drawing on the prepared board or canvas, usually with a worn, short, flat brush, to place the most important directional lines and outlines. Then I consider the extremes of warm and cool colours and lights and darks, which will give me a reference within which to work as I block in the main shapes of the painting. Once I am happy with the tonal balance, and with all the basic painting in place, I can return to the studio to complete the painting.

Below *Café Study, Alcudia, Mallorca*
Oil on linen canvas
40.5 x 51cm (16 x 20in)
Another good idea for studio work is to try a different interpretation of a plein-air painting, perhaps on a larger scale or in a different medium. For this oil painting, I worked from the watercolour version that was mostly painted on site – see page 36.

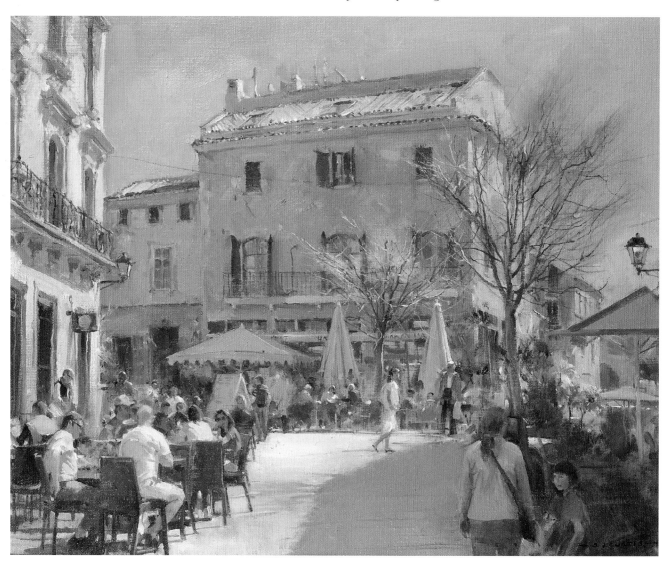

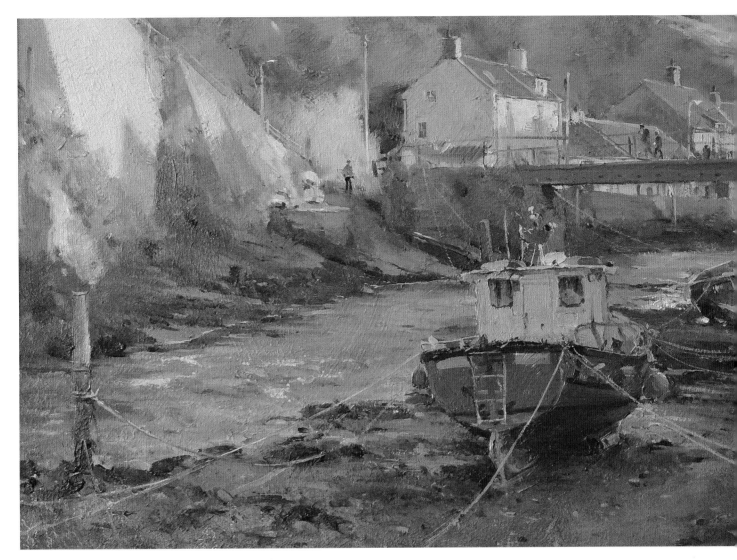

Resolving ideas

Shadows on the Sea Wall (above) is a 'middle way' painting. I spent just over an hour painting this on site and then a further four or five hours in the studio. As you can see, it was a complex subject and there were also considerations about the light and tide. Also it was quite late on a cold winter's day when I spotted this subject, so the conditions were not conducive to staying out very long.

I managed to complete the basic blocking-in on site and then I was able to take my time in the studio to work on the subtleties of light and dark, the lost-and-found effect on the boat, and the general details and surface variations. Because it was a Staithes subject, I had a lot of other paintings in the studio that I could refer to. Success with this painting depended on capturing the particular quality of light, and I was careful not to labour this. I wanted to convey the intriguing sense of mood and atmosphere that initially inspired me to paint the subject.

Above *Shadows on the Sea Wall*
Oil on board
25.5 x 35.5cm (10 x 14in)
For more complex subjects, try the 'middle way'. Do all the foundation work on site and then complete the painting in the studio with help from sketches and photographs.

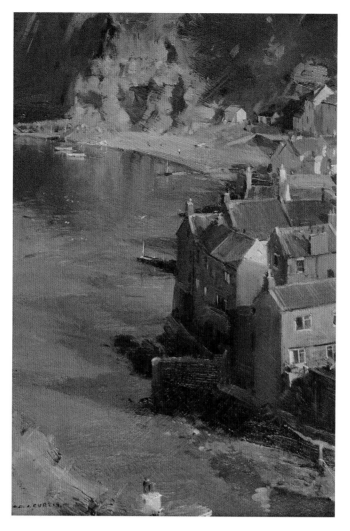

Right *High Viewpoint over Staithes Harbour*
Oil on board
20.5 x 30.5cm (8 x 12in)
I painted this entirely on site. I particularly liked the effect of the light and the composition in this subject, which I then thought I would like to try as a studio watercolour.

Plein-air and studio work

Small *plein-air* paintings, sketches and studies make excellent starting points and reference material for larger-scale and more resolved paintings in the studio. However, before making a start on the studio painting, always check that the *plein-air* idea you have chosen will suit being enlarged. What works well on a small scale may not have sufficient content and impact to succeed on a bigger scale. You may have to expand on the original *plein-air* subject, perhaps to include figures and more detail, for example. Similarly, you may need to adjust the composition, again perhaps involving additional elements, so that it works successfully with the new scale and format. Here is an opportunity to be creative and inventive, to draw on all your skills and to make use of whatever reference material you have managed to build up – sketchbooks, drawings, paintings and photographs.

Painting from location studies

An alternative approach is to reinterpret a *plein-air* painting in a different medium back in the studio. Again, particularly if you are going to try a larger painting, you may want some additional reference material to help further inform the content and composition. And, of course, you may need to create a different emphasis and mood for the painting in keeping with the character and potential of the new medium. It is a great exercise to try. But, whether you change the medium or not, everything you paint in the studio from *plein-air*

reference should have an added value – it should take the idea further and lead to a more considered and imposing result.

For the studio watercolour painting *High Viewpoint over Staithes Harbour* (page 127), my only source of reference was a small 20.5 × 30.5cm (8 × 12in) oil study, which I had produced on site (shown opposite). I thought the subject would work equally powerfully using the more fluid medium of watercolour and I wanted to preserve the sense of mood and place that I had managed to achieve outside. So, with the *plein-air* study to guide me, I painted as though I were still there, in front of the scene, experiencing all the mood and atmosphere of the place.

For a change, I tried Fabriano paper. This gives some wonderful effects with transparency and granulation, although generally it is not as tough as some of the other papers I use and therefore more care is required when applying the colour washes. As I normally do, I started by making a pencil drawing on the watercolour paper to give a clear indication of the composition and to help me identify the extreme light areas (Stage 1, above left). I felt that there was no need to change the composition from the original *plein-air* version: it was a lovely arrangement and required no improvement. Once the drawing had been completed, I masked out the lightest areas using tinted masking fluid. An advantage of using watercolour, I thought, was that I should be able to achieve a convincing feeling for the shadows later on, with superimposed washes of cobalt blue and cobalt violet.

Next, I applied the 'ghost' wash, paying particular attention to the main colour changes as I worked my way down the painting (Stage 2, above right). For the ghost wash I always

Above left *Stage 1*
I started with a pencil drawing to indicate the principal shapes and the rhythm of the composition.

Above right *Stage 2*
Next, I applied the initial 'ghost' wash, chopping and changing the wet-into-wet colours as necessary as I worked my way down the painting.

have big wells of colour ready-mixed – in this case, raw sienna, cobalt blue, cobalt violet and viridian. I dip my brush into whichever colour is appropriate for the area I am working on, and so finish with an overall wet-into-wet variegated wash that gives a general impression of the colours and tones that I need to develop. Where I need to indicate a brighter or stronger colour, I add a touch of, for example, vermilion or cadmium yellow, into the wet wash.

After leaving the painting to dry and rubbing off the masking fluid, I concentrated on placing the darks (Stage 3, above left). With no sky area against which to assess the tonal values, I felt that there was a danger of making the background too strong and so limiting any sense of space and depth. So it was important now to register the foreground darks accurately, as this would give me a reference for the tonal values in the rest of the painting.

Stage 4 (above right) was a very busy stage. I added the warm colour to the roofs, worked on the background and applied the first shadow wash to the water. Almost the whole surface of the painting received some additional work, with the emphasis on pure, crisp colour. And the final stage, as you can see in the completed painting, *High Viewpoint over Staithes Harbour* (opposite), was all about modelling, firming up and detail. For example, I added a few figures – just tiny dots to create a sense of life – and applied a graduated wash, from the middle distance right down to the foreground, to enhance the translucent quality of the water. Although I had produced the painting in the studio, I felt that I had managed to retain that sense of immediacy and place that defines the true *plein-air* experience.

Above left *Stage 3*
By placing the foreground darks, I established a reference for the tonal values in the rest of the painting.

Above right *Stage 4*
Now I could work across the whole painting to develop more definition, and with an emphasis on crisp, pure colour.

Opposite *High Viewpoint over Staithes Harbour*
Watercolour on Fabriano paper
38.5 x 28.5cm (15¼ x 11¼in)
I added a few details and finishing touches. I felt the painting worked reasonably well: true to the watercolour medium, it had a lovely atmospheric quality.

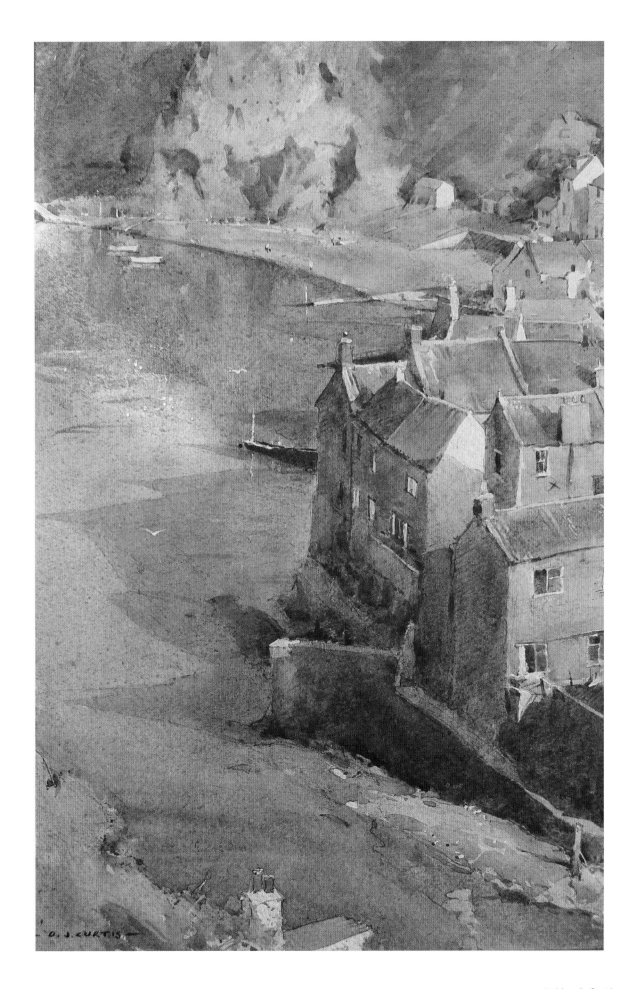

O. J. CURTIS

Index

Page numbers in *italics* refer to illustrations

26